MICHAEL FREEMAN
THE LOW LIGHT
PHOTOGRAPHY
FIELD GUIDE

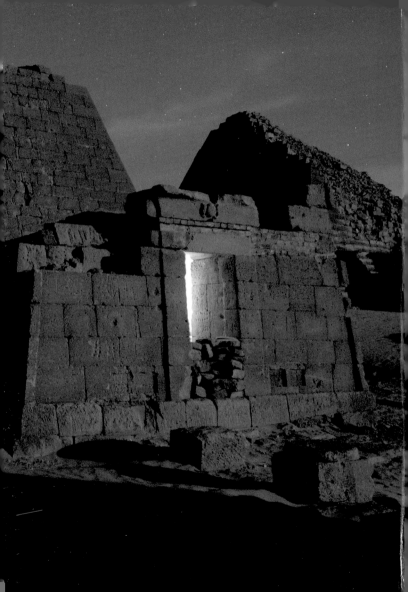

MICHAEL FREEMAN
THE LOW LIGHT PHOTOGRAPHY FIELD GUIDE

Go **beyond daylight** to capture stunning low light images

ELSEVIER

AMSTERDAM • BOSTON • HEIDELBERG • LONDON
NEW YORK • OXFORD • PARIS • SAN DIEGO
SAN FRANCISCO • SINGAPORE • SYDNEY • TOKYO
Focal Press is an imprint of Elsevier

Focal Press

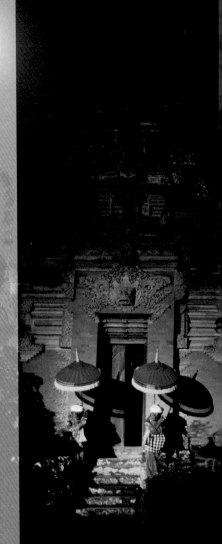

Focal Press is an imprint of Elsevier Inc.
225 Wyman Street, Waltham
MA 02451, USA

This book was conceived, designed,
and produced by Ilex Press Limited
210 High Street, Lewes, BN7 2NS, UK

Publisher: Alastair Campbell
Creative Director: Peter Bridgewater
Associate Publisher: Adam Juniper
Managing Editor: Natalia Price-Cabrera
and Zara Larcombe
Editorial Assistant: Tara Gallagher
Art Director: James Hollywell
Designer: Jon Allan
Color Origination: Ivy Press Reprographics

Library of Congress Control Number:
A catalog record for this book is available from the
Library of Congress.

ISBN: 978-0-240-82080-4

For information on all Focal Press publications visit our
website at:
www.focalpress.com

Printed and bound in China

10 11 12 13 14 5 4 3 2 1

CONTENTS

INTRODUCTION

In previous books, by and large I've divided the subject
between shooting and post-production, a logical
sequence that starts with the actual photography
and moves through to the various ways of managing
and optimizing images on the computer. The skills
are different, as is the place and time, and so this
makes sense.

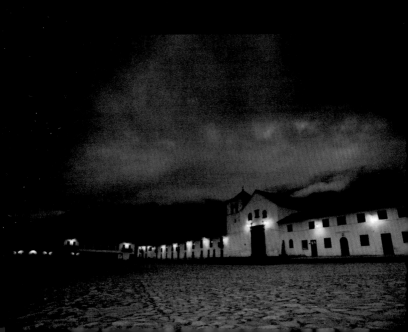

Here, however, I deliberately mix post-production and computer work in with the shooting. I've taken a conscious decision to do this because digital photography is no longer a new, high-tech version of old photography. For most photographers it is now photography, pure and simple. Moreover, I am also thinking about who the audience for this book is. Low light photography is specialized, and certainly more demanding technically than most other forms. I think it less likely that you will dive straight into this book as your first serious experience in photography than the more predictable route of exploring a new area having already mastered the basic techniques. Here I have stepped right over these basic techniques, and have skipped the primer stages of setting up the computer and familiarizing yourself with image editors such as Photoshop, and so on. For anyone expecting this, I apologize, but would direct them toward other volumes more suitable for beginners.

Also, dealing with software and post-production in the same breath as shooting techniques more accurately reflects the way that professionals shoot. A theme I've probably worn threadbare elsewhere is that successful digital photography above all demands anticipation—knowing in advance what you can do later in post-production. Nevertheless, I'll repeat it here, because low light photography in particular has to deal with the limits of acceptable imagery. There is a good deal of problem-solving involved in this kind of photography, and a large part of the work has to happen on the computer. So, it's essential to know at the time of shooting just how much, for example, you can expect to open up dark shadows or recover highlights from a streetlamp.

LOW KEY

The cobbled plaza of the traditional colonial town of Villa de Leiva in Colombia helps lend atmosphere to this low-key, low-light photograph.

LOW LIGHT

The ends of the day, life indoors and the entire range of night-time activities offer a rich and large source of subjects for photography, now more accessible than ever before. And it is digital photography, with its many continuing advances that has made it more accessible. What we are talking about here is extending the shooting range into situations that, because of insufficient light, could not be handled as freely as film photographers would have liked.

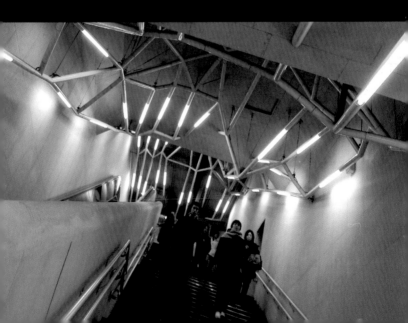

Photography has always had technical limits, but then photographers have always learned to accommodate and work within them. In fact, they are not always thought of at the time as limits, and it is only when these are about to be broken, or have just been broken, by technological improvements that we can see just how restricting they have been. The quantity of light and the sensitivity of the recording medium has always been one of the most basic limitations. In the early days of photography, it restricted shooting to bright daylight, and even then the exposure times were not short. As film emulsions improved in sensitivity, and as lenses became faster and cameras smaller, it became possible, but only just, to shoot in artificial light. The first photojournalist was, arguably, Eric Salomon, who made use of the 1924-designed Ermanox 858. This camera, designed by Ludwig Bertele, had a maximum aperture of f/1.8 and shutter speeds up to 1/1200 second, making it possible for Salomon to capture his celebrated "candid" pictures of society life in Berlin. Developments were rapid, and Leica soon announced a camera with similar capabilities that accepted the more convenient 35mm film rather than rigid plates.

Digital photography and its recent changes have ushered in a new era in low light photography by extending the range of time and situations that can reasonably be captured, making it possible to use a camera under conditions that would have been unthinkable without resorting to invasive techniques such artificial setups and flash. Sensor sensitivity has improved hugely in recent years, and this, combined with new in-camera and post-production processing, has reduced the collateral damage to images from noise—a major preoccupation in this kind of shooting, and in this book. In this first chapter, we'll look at how the digital process—from sensor to in-camera processing, to post-processing—handles light when it comes in quantities significantly less than during a normal day.

ARTIFICIAL LIGHTING
Shooting interiors can often present white-balance challenges due to artificial lighting, as well as those of low light levels.

Light on the Sensor

As we'll see throughout this book, low light photography pushes limits. It pushes the limits of technique, demanding constant attention to steadying the camera, subject movement, and changing camera settings to suit the conditions.

It also pushes the technical limits, beginning with the sensor and lens. The special conditions found in many low light situations tend to highlight deficiencies of the sensor. Notable among these are blooming and noise. In effect, these operate at opposite ends of the brightness range; blooming is flare surrounding overexposed highlights, while digital noise is at its most apparent in the shadows, in longer exposures, or at higher sensitivities.

Blooming is the leakage from a photosite on the sensor that has reached full capacity (complete white) into adjacent photosites.

High-quality sensors show less of this than cheaper ones, but some flaring is inevitable in the typical low light situation where there are bright lights against dark backgrounds. The city night view here is typical. Nevertheless, we are so accustomed to seeing flare in images that it is not necessarily a problem. In most photographs, the flare from the lens is greater than that from sensor blooming.

Another defect noticeable in isolated highlights—or along strong luminosity edges—is chromatic aberration. There are two kinds, axial and lateral, and in modern lenses it is the lateral aberration that tends to be the culprit. The role played in this by sensor blooming (see box below) is disputed, and is probably tied to a different aberration known as "purple fringing." Lateral chromatic aberration shows itself as two opposed colors, usually red-cyan or blue-yellow, and is

Sensor blooming and purple fringing

Another detail from the Tokyo night shot, highly magnified, shows the effects of blooming, or flare, when highlights are overexposed. Sensor blooming occurs when photosites fill up and the charge leaks to adjacent wells. The left image was shot at 1/3 sec and the center one at 2 sec. In the 2 sec exposure light is spilling over from the edges of the neon display. The right-hand image is the 1/3 sec exposure processed for an increase of nearly 3 stops to bring it to approximately the same brightness as the center. This creates a very noisy image with exaggerated fringing, but blooming is not noticeable to the same degree.

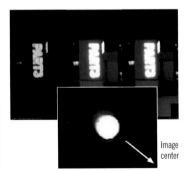

Image center

PURPLE FRINGING
This detail of a light source from a night shot shows purple fringing, believed to be caused by sensor blooming or from the microlens, or both. It differs from normal chromatic aberration in that it is a single color in one direction.

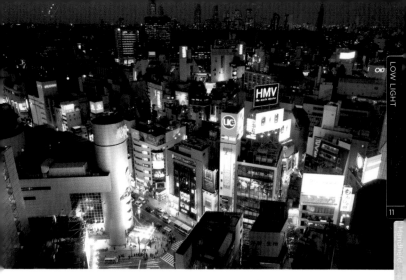

CHROMATIC ABERRATION
A night view of Shibuya, Tokyo, shows lateral chromatic aberration from a wide-angle zoom.

increasingly common because of wide-range zooms, which are difficult for lens manufacturers to correct across the range. Also, every photographer is now a few clicks away from a magnified view of every image, so these things are simply noticed more. There are several solutions depending on the software. Most typical is a manual operation, moving a slider, and this works by expanding one channel relative to another. There is also defringing software that works on the edges themselves. A more automated solution is to use a pre-calculated lens module that corrects for the aberration in known lens-camera combinations, such as DxO Optics Pro and Lightroom.

Noise is one of the special problems that arrived with digital photography, although it is less of an issue now. It appears as a random pattern of pixels, usually bright and multicolored, superimposed on the image. The comparison that is frequently made with grain in film is far too generous, as grain structure in an emulsion can contribute a gritty texture that is possible to like. Nobody to my knowledge has ever made a case for digital noise being aesthetically pleasing. In terms of appearance (rather than cause), there is luminance noise (the random pattern of pixels varies from dark to light), chrominance noise (the pixels vary in hue), "dead" pixels (bright dots) and JPEG artifacts, if you shoot JPEGs (blocks of 8 × 8 pixels can be prominent as these are used in the compression). Noise is a particular issue for low light photography because whether you increase the ISO for handheld shooting, or increase the exposure time for tripod-mounted shooting, noise will be created.

Digital noise

A simple comparison of noise at different camera settings. Noise is always most apparent in smooth areas that are dark, but above black. Practically, the major difference in noise comes from changing the ISO sensitivity. This sequence runs from an ISO setting of 100 to 6400. A point to note is that in terms of appearance, these noise effects are exponential—meaning they set in quite late on the scale, but at the high end of ISO choices quickly become objectionable.

The second most common kind of noise is dark noise from long exposures, and here, at a one-minute exposure, the noise is less of an issue with this sensor and this camera than the random noise from high ISO. There is a barely noticeable difference between the camera's dark-frame

subtraction process switched on and switched off. The temperature is critical, however. This sequence was shot at a reasonable room temperature of 21°C, but this kind of noise tends to double every 6°C to 8°C.

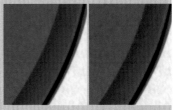

LONG-EXPOSURE COMPARISON
Left is 60 sec NR on, while right is 60 sec NR off.

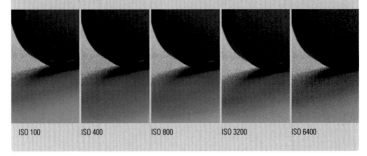

| ISO 100 | ISO 400 | ISO 800 | ISO 3200 | ISO 6400 |

We will look at noise and noise reduction in detail in Chapters 2 and 3, but in practical terms it is essential to be thoroughly familiar with the appearance of noise as created by your camera in images that you typically shoot.

Few people would disagree that noise is best avoided, but the amount of effort you go to in order to control it should depend on how important it is to you. Long-exposure noise

can generally be taken care of quite well in the camera by selecting the noise-reduction option in the menu, but the immediate cause of most noise is setting a high-ISO sensitivity. You may well find that for certain kinds of image, you can tolerate a higher ISO setting than you imagined. As an important first step, make some tests at different ISO settings in a range of low light situations, and examine them

THE CASE FOR LOWER KEY

For shots taken in low light to convey that impression, the key of the finally processed image needs to be lower than normal. This is entirely a matter of taste, but here, the darker of the two versions is more faithful to the original impression—something that only the photographer can decide. The histogram is always a good check—the bulk of the tones centered is a normal key; shifted to the left is low key.

side by side. At 100 percent magnification, you can expect to see increasing noise with higher-ISO settings most obviously in smooth shadow areas. Decide for yourself at what setting it becomes objectionable. As noted on the previous pages, you need to find an acceptable balance between the usefulness of a high-ISO setting and the degree of noise.

There are several variables when it comes to making this decision. One is the medium that you would normally use for displaying your images. If this is a print, then you should make tests using your preferred paper type. The appearance of noise will be different between a 100 percent screen view and a print. A related variable is the size at which the images will be used. A fully magnified print will obviously show more noise than a 640 × 480 pixel screen image posted on a website. A third variable is the kind of image. A reportage shot with visible noise is likely to be tolerated by more people than would be a still life or landscape. Yet another variable is knowing how much you can expect to, or are willing to, reduce the noise later with software.

Ultimately, when shooting, you should be armed with enough information and judgment so that you can confidently select the appropriate ISO setting. You may, for instance, see hardly any difference in noise between shooting at ISO 100 and ISO 200, in which case the extra shooting speed carries no penalty. The ISO setting is one of several ways of achieving a certain shutter speed, and the others include supporting the camera, sacrificing depth of field by opening up the aperture, and switching to a faster lens. Each carries some disadvantage, even if minor, so consider the ISO selection in this context. Maximizing shooting efficiency may mean altering the ISO frequently, and some cameras allow it to be changed by means of a dial, which is faster than going to the menu.

As well as technical matters of exposure, such as holding highlights and avoiding shadow noise, which are all the more critical with artificial light sources, you need to decide whether a scene should look dim rather than fully bright—in other words, the key of the shot. With a night image, this is perfectly expected—it would look strange otherwise—but there are many less obvious situations where there is room for interpretation. The example I've chosen here is deliberately not a clear-cut case: a Hakka communal dwelling in China, where the atmosphere inside the circular three-storey structure, open to the sky, was distinctly subdued.

Thresholds and Trade-offs

In one important sense, low light photography is not just another situation, or just another themed area of photography. It carries with it a challenge; that in order to work in these lighting conditions you are forfeiting predictability.

The lighting conditions themselves are never quite sufficient to allow the perfect camera settings, so not only are you close to reaching the shooting limits, but you will always have to make technical compromises. If you sacrifice shutter speed, you run the risk of motion blur or camera blur. You can trade this against a number of other things, including aperture, noise from a higher ISO setting, lens focal length, viewpoint, the moment of shooting and more besides. The list of choices go on, and are always specific to the scene in front of you. The point I'm laboring here, because I think it worth a couple of pages, is that low light photography

has built into it the idea of pushing the envelope. The reward, as just mentioned, is being able to work in, and capture, an area of life, that was up until recently fairly restricted to photography. The price is a higher level of concentration on technical matters, and a higher failure rate, which simply takes some getting used to.

Photography as a whole is premised on there being enough light to work easily, and the norm is full daylight. There's no precise definition for this, but it goes from around 8 a.m. to 5 p.m. Not surprisingly, cameras and their sensors are designed for trouble-free operation in these conditions, meaning that the sensor can operate at its lowest, cleanest sensitivity for highest image quality and yet still allow a choice of shutter speed and aperture. These in turn give you flexibility in capturing motion and in deciding on the appropriate depth of field. In order to shoot

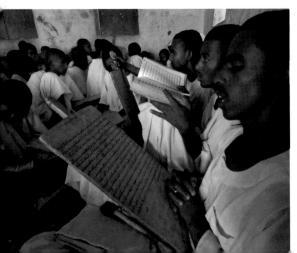

WIDE ANGLE, LOW LIGHT

The compromise in a shot like this, taken with an 18mm EFL lens, is between depth of field, subject movement, and noise, affecting aperture, shutter speed, and ISO. Of the several possibilities, I chose ƒ/5.6 with careful focus, 1/10 sec and ISO 400. In other words, I favored low noise, and shot many frames to guarantee the final image.

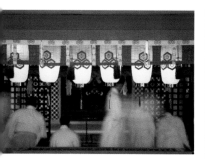

USING MOTION BLUR DELIBERATELY
Turning the problem around creates new opportunities. In this situation, of priests at prayer in a Shinto shrine, the camera was mounted on a tripod and the shot was framed to include a significant part of the setting (which remains sharp), while the white-clad figures flow insubstantially in a one-second exposure.

Freezing movement

The following factors affect the shutter speed:
- How fast the subject is moving
- The angle of movement to the camera: head-on, side-on, or diagonal
- Distance from the camera
- Focal length of the lens

In addition, the following set limits to the speed that is actually possible:
- The need for good depth of field (from a smaller aperture)
- The amount of acceptable noise
- The amount of acceptable motion blur
- The amount and direction of light
- Size of reproduction or viewing of the final image

successfully in the more restricted conditions of low light, you lose any flexibility. On the contrary, none of the settings are likely to be what you would really like.

Because low light photography is constrained somewhat by performance limits, shooting always involves compromise, and adjusting the camera settings to sacrifice one technical function in favor of another. These are the trade-offs, and it's easy to see them as a permanent set of difficulties, but practically it usually works better to treat them more positively, as ways of getting you closer to images that are only recently possible.

In a wider sense, all good photography pushes limits of one kind or another. Whether these are creative limits, like composition, or technical limits (as in low light) is not a great distinction, because each affects the other. Pushing the technical limits of shutter speed

and aperture, and having the ability to handhold steadily and choose the right settings for the situation ultimately contributes to the creative success of an image. At this edge of technical acceptability there are bound to be failures and disappointments— perhaps many for each shot—that make this edge-pushing worthwhile. If you feel this, and are happy living with the uncertainty, low light photography will give you a permanent level of excitement.

Handheld

Locked Down

The Range of Light Sources

By definition, the quantity of light is always much less than the reference standard for photography and human vision alike—the sun. Midday sunlight, clear and unfiltered by clouds or haze, produces around 100,000 to 130,000 lux (see box).

The lighting in a typical office is probably between 200 and 400 lux, so the difference between the two in practical photographic terms is about EV 7 or 8. Put even more practically, at ISO 100 a typical setting for bright midday would be 1/125 sec at f/16, while in an office you would be shooting at, say, 1/15 to 1/30 sec at f/2.8 at the same level of sensitivity.

One consequence of this is that in low light there is no typical, easily predictable setting. Levels vary hugely, as the table opposite shows. Not only this, but the illumination from all local light sources, as we'll see on the following pages, tends to be uneven. The illumination fades rapidly with distance from each lamp. The most common artificial light sources, which we'll examine in detail in Chapter 2, are vapor-discharge lamps of several varieties, fluorescent lamps, and incandescent lamps. Many interiors and night-time exteriors have a mix of these light sources, which under some circumstances can create interesting and attractive visual effects, but which can also be a headache for tonal and color balance.

Light sources vary not only in intensity but in the color of the light they emit. The human eye manages to accommodate these differences so well that for the most part we are unaware of any major difference, other than perhaps a "warm" appearance from incandescent lighting and a slightly "cool" effect from fluorescent lamps and vapor-discharge lamps. However, the camera's sensor captures the true emission, unfiltered by our complex eye-and-brain processing.

FLAME

Flame is the basic, original artificial light source, and still features occasionally in low light photographic situations.

TUNGSTEN

The range of tungsten lamps for domestic use is typically between 40 and 100 watts, and in color temperature between 2750 K (40 watts) and 2850 K (100 to 150 watts). However, fittings such as lampshades reduce and diffuse this output, and introduce color shifts.

Low light levels

The fundamental measurement unit of scene brightness is the lux. This is one lumen per square meter, and measures the amount of light falling on a scene. It has nothing to do with the light reflected from surfaces, takes no account of what is in the scene, and is akin to an incident light reading (as taken with a handheld meter). The unit more familiar to photographers is EV, or Exposure Value, and the values given here relate to surfaces in the scene, and assume average reflectivity. EV varies according to the sensitivity to which the camera is set, and the single figures given here assume ISO 100. Doubling the ISO would increase the EV by 1. EV can also be expressed more practically as a combination of shutter speed and aperture, and the examples given here are only one of many combinations. Thus, EV 7 at ISO 100 could be 1/15 sec at f/2.8, or 1/30 sec at f/2, or 1 sec at f/11, for example.

Lighting situation	Lux (light falling on scene)	EV (Exposure Value) at ISO 100	Typical speed & aperture at ISO 100
Television studio	1,280	EV 9	1/60 sec f/2.8
Indoor office	320–640	EV 7–8	1/15–1/30 sec f/2.8
Dark, overcast	80–160	EV 5–6	1/4–1/8 sec f/2.8
Twilight	10	EV 2	2 sec f/2.8
Deep twilight	1	EV -1.3	20 sec f/2.8
Average full moon	0.3	EV -3	1 min f/2.8
Average quarter moon	0.03	EV -6.5	12 min f/2.8

CFLS

CFLs (Compact Fluorescent Lamps) are becoming increasingly common in domestic interiors for their efficiency and low heat output. However, they cause difficulties in color rendering in photography, because they lack a full spectrum.

Contrast Issues

The illumination from any light source falls off with distance, which is fairly obvious if you think of a flashlight aimed out into the dark, or the way a room looks when only one table lamp is switched on.

In daylight photography this is not a consideration, because of the great distance of the sun. Any difference between the sunlight reaching a mountain top and that at sea level is insignificant compared with the 93 million miles between the sun and earth. Photography by any kind of artificial lighting, which covers the majority of most peoples' low light shooting, has to deal with a very different distribution of illumination.

The light fall-off from a point source of light, such as a bare bulb, follows a simple law. It fades in inverse proportion to the square of the distance, hence the name the Inverse Square Law. So, for example, the illumination two meters away from a lamp is four times less than at one meter (1×1 m = 1, 2×2 m = 4). Put more pragmatically, light falls off rapidly, and the result in city streets at night and interiors with mainly spotlighting, such as restaurants and clubs, is a lighting pattern of pools of light surrounded by shadows. More lights add to the complication of the lighting design, and broad area lights such as diffuse, concealed ceiling lighting, lessen the fall-off. The net result is more often than not a high degree of local contrast.

This is one of the most basic technical issues in low light photography, and many of the techniques in this book are aimed at dealing with it. High contrast means not only that the dynamic range of a scene may be beyond the ability of the sensor to capture it in one exposure, but that there are likely to be significant shadow areas where detail is lost and where there is visible noise. The

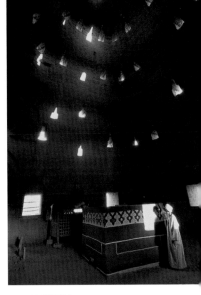

HIGH CONTRAST
Sunlight streaming through an array of small triangular openings in a Sudanese tomb create an unusual and attractive effect. When contrast is very high, yet the darker areas dominate, the best strategy is to let the highlights go.

situation is made even more difficult when light sources themselves appear in shot—street lamps, downlighters set into ceilings, neon display advertising, and similar. The traditional ways of dealing with bright pools of light and dark shadows focus on composition and viewpoint, such as moving the camera to hide a bright spotlight. Composition can also make use of the chiaroscuro effect of light and shade, and to an extent some area or areas of dense shadow and lost, burnt-out highlight can be acceptable in the image.

Nevertheless, digital techniques, both in capture and post-production, offer another way out of this situation, by

Balancing mixed light

To the eye, a living space like this, partly lit by subdued daylight, and with white walls helping to even out the illumination, appears reasonably balanced. A photograph, however, reveals the concentrated high illumination from spotlights and lamps, which tend to burn out in the image. New techniques of blending a dark and a light exposure, however (see pages 52, and 158–173), achieve a more balanced effect that represents more accurately our visual impression.

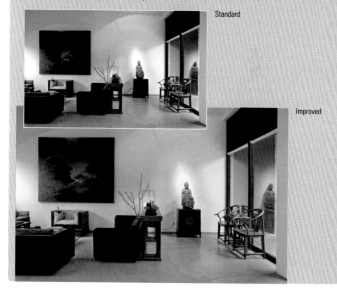

Standard

Improved

effectively increasing the dynamic range. HDR Imaging, for example, in which a sequence of exposures is captured, then compressed into a single image file, covers a very wide dynamic range. Shooting Raw also potentially offers a higher dynamic range, although it depends on the exposure at capture as a completely clipped highlight is not recoverable. There is also the Shadows/ Highlights control in a number of editing packages. Either way, post-production offers an increasing array of smart techniques for doing the two things that were virtually impossible on film—restoring highlights and opening up shadows.

Restoring Highlights

In order of priority for human perception, the midtones of an image are naturally the most important as they usually contain the most detail, but they are followed closely by highlights, with shadows in last place.

Apart from light sources themselves, such as lamps, which are expected to be super white, we tend to sense something wrong in an image where the highlights are well overexposed. Dense shadows without features are more easily tolerated. This, more than anything, is the basic rationale for exposing to hold the highlights.

Nevertheless, there is a range of post-production techniques for recovering detail in highlight areas. All are premised on there being some detail captured. As we've seen, a completely blown highlight (255, 255, 255 in RGB) is simply empty space in the image. Once a photosite has filled up completely, there is no recovery possible. If one channel has blown, and sometimes if two channels have blown, there is some recovery possible in Raw, but this is the limit.

The Raw converter is indeed the place to begin highlight recovery if you are shooting

Flames

In this shot of firecrackers being thrown into a furnace in a Chinese temple, the flames are very overexposed, but recovery of sorts is possible.

Using Lightroom delivers an improvement, achieved by increasing Recovery to the maximum, decreasing Exposure and increasing Brightness.

this format. The more advanced image editors have algorithms for attempting to reconstruct image detail from the remaining channel or channels. Lightroom and Aperture, for example, have a specific Recovery slider for this. Dragging it to 100 percent will also affect midtone areas, but these can be pulled back with either or both the Fill Light and Brightness controls.

With TIFFs and JPEGs, the most basic technique is an adjustment in Curves. For maximum control first sample the areas of highlight that you want to alter, in order to define exactly which section of the curve to

drag. Anchoring other parts of the tonal range by selecting points on the curve below and even above this section will help to constrain the effect. However, curve adjustments tend to carry some unwanted side effects, like lowering contrast. Some recent methods are starting to make Curves look primitive.

These methods of altering tonal range take account of the spatial location of each pixel, and are a form of local operator. Probably the best-known is the Shadows/Highlights control found in a number of programs. However, extreme settings can produce unrealistic results.

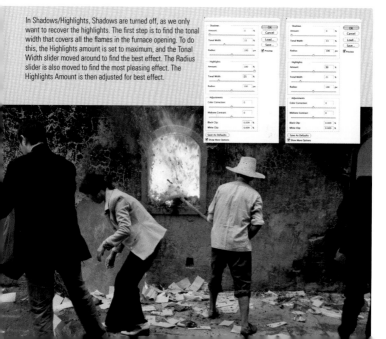

In Shadows/Highlights, Shadows are turned off, as we only want to recover the highlights. The first step is to find the tonal width that covers all the flames in the furnace opening. To do this, the Highlights amount is set to maximum, and the Tonal Width slider moved around to find the best effect. The Radius slider is also moved to find the most pleasing effect. The Highlights Amount is then adjusted for best effect.

Revealing Shadows

As with highlight recovery, if your exposure has been made for the midtones, as is usual, there will often be a need to lighten the shadows in a high-contrast image.

As just explained, dense shadows are perceptually more acceptable than washed-out highlights. At the same time, there is usually more that can be recovered, as there are usually some photons of light that have entered even the darkest photosite on the sensor. Practically, this means that it is usually easier in most images to pull more detail out of shadows than out of highlights. There is an important limitation, however, which is that the most noise is in the shadow areas, and any enhancement of shadow detail will exaggerate this noise. In the darkest shadows, the signal-to-noise ratio may be so low as to mark the limits of useful image. So, any shadow recovery technique usually benefits from noise reduction as well.

The techniques are similar (though in reverse procedure) to those for highlight recovery, beginning with the Raw converter. In Lightroom, the relevant slider is Fill Light. Understandably, it has a slight flattening effect on the dark-to-mid tones, and may benefit from some contrast enhancement. The upper set of sliders in Photoshop's Shadows/Highlights control work as the Highlights do (see page 24).

Finally, it's worth mentioning in this context another local contrast enhancement technique that is really an unintended by-product of sharpening. This extremely useful technique is applied through the standard sharpening method known as Unsharp Mask (USM). While seemingly different in purpose, sharpening and local contrast enhancement are very closely related. Both depend on creating a soft mask, across which the contrast is increased. In USM, the contrast increase is on a very small scale—often a radius no more than one pixel—but quite strong, so that edges become more pronounced. In local contrast enhancement, the settings are reversed, with a very large radius, often as much as 100 pixels, but a small amount. The effect is larger-scale transitions, but without altering the global contrast of the image, and is typically subtle. In both, some pixels cross over each other in the histogram, making this completely different from a curves-based adjustment. The latter, one form or another of an S-curve, is a truly global adjustment.

Other image-editing software offers alternative techniques for opening up shadow areas, generally through either lightening a selected area or by means of tone mapping and accentuating local contrast. The two programs featured here are both aimed at photographers in the sense that they deliberately avoid the Photoshop way of working. In different ways, they attempt to be intuitive and automated, so as to speed up processing decisions. In the course of doing this, many of the arcane parameter sliders and tools common in Photoshop are concealed, or at least pushed into the background. This applies to shadow control as much as other procedures. DxO Optics Pro has very little showing in its controls that appears to be specifically aimed at opening up shadows, but the algorithms are there nevertheless. They are included in DxO Lighting tools, and the principle they use is segmentation, in which the image is analyzed for different ranges of luminance values, and these are then each treated slightly differently.

Raw shadow recovery

Lightroom default

Lightroom with Fill Light at 25

Handheld

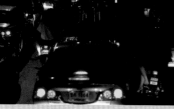

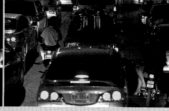

Before: LightZone offers another option, Relight, which performs a similar procedure to DxO.

With Relight

Locked Down

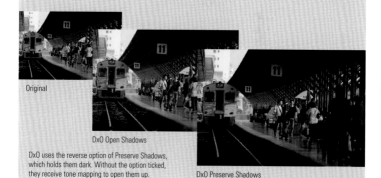

Original

DxO Open Shadows

DxO uses the reverse option of Preserve Shadows, which holds them dark. Without the option ticked, they receive tone mapping to open them up.

DxO Preserve Shadows

Shadow areas are generally given an increase in lightness and the tone curve slope. The choices Slight, Medium, and Strong then apply these, as well as other automatic adjustments, to different strengths accordingly. In addition, unchecking the Preserve Shadows checkbox opens them up even more, at the slight risk of a loss of naturalness.

LightZone offers more than one method of opening up shadows specifically. One is the Relight tool, which uses tone mapping techniques similar to those seen in high-dynamic-range software to lighten shadow areas while maintaining the local contrast in the image (and the reverse for highlights).

Another is LightZone's basic Zone System approach to tonal adjustment, whereby a zone can be selected and dragged up or down in the scale to lighten or darken just those values. Yet another option is the distinct High-dynamic-range/Dark-scene "style," one of a number of presets that opens up a tool giving options for adjusting shadows.

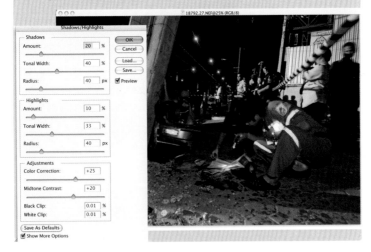

Shadows/Highlights

Photoshop's post-processing option applies tone mapping selectively to darker and lighter areas.

Subtle recovery with a luminosity mask

This very gentle effect is achieved by first creating an inverted Luminosity mask, and then applying USM at low intensity and high radius.

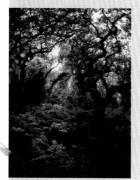

Original

Clicking this symbol creates a luminosity mask of the lightest 50 percent.

Invert the selection to select the darkest 50 percent of the image.

USM applied to subtly add contrast to the shadows only.

Shadow Realism

Over the last six pages we viewed a number of powerful post-production tools for recovering lost detail and enhancing limited detail at either end of the tonal scale.

Because of the nature of low light photography and its typical situations, shadows play a very large part in the image. The efficiency of image-editing software in pulling detail out of shadows makes it tempting to use aggressively, but this carries some dangers. One obvious problem is the enhancement of noise. Even when noise is fairly evenly distributed across an image it is not particularly attractive. When it is concentrated very noticeably and patchily in the shadow areas, it is even worse.

But beyond this, there is the more subjective issue of what looks right in an image. This is impossible to quantify, because it varies from viewer to viewer, and is affected not only by what we consider to be the normal, realistic appearance of a scene, but also by the way we have become accustomed to seeing photographs. In a sense, shadow recovery techniques are a small but important part of the much bigger issue of tone mapping HDR images. The effect that shadow recovery has is the appearance of more visual information, but not necessarily a more truthful, convincing, or even aesthetically pleasing image. The sequence of image adjustments shown here makes this obvious. As the recovery procedure is applied more intensely, the shadow areas throw up more and more detail, but at a certain point they begin to look false. Exactly which step looks false to you is a matter of personal judgment, but it has become one of the most common and glaring "faults" seen in today's digital image processing, especially with low light pictures.

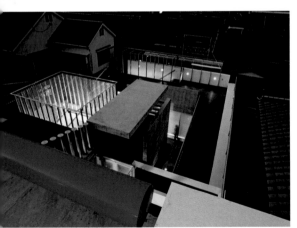

JUDGING THE EXTENT OF TONE MAPPING

Using Aperture's Highlights & Shadows for shadow recovery only, this series of different amounts shows that while increasing the number of opened-up shadows obviously reveals more and more detail, at a certain point the image will begin to look artificial and lacking in traditional photographic qualities.

Aperture's Highlights & Shadows

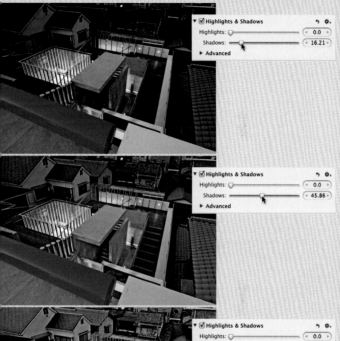

Color Temperature

Color temperature is arguably more important in low light photography than in any other, because the range of light sources you are likely to encounter varies widely on this scale.

First though, with apologies to all those people who know this already, a brief primer on the color temperature scale, and the reasons why it has a place in photography. It all starts with the sun, which is the reference standard in several ways for human vision. Its light, at least when it is high in the sky, is what we call white. As this light is created by burning—incandescent, in other words—there is an exact correlation between temperature and "whiteness." The unit of temperature used is the Kelvin, which is basically similar to Celsius/Centigrade but starts at absolute zero (-273°C). Something burning at a lower temperature than the sun, such as a candle,

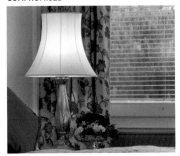

COMPROMISED

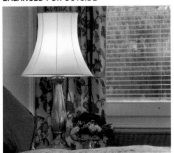

BALANCED FOR OUTSIDE

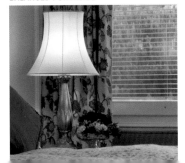

BALANCED FOR INSIDE

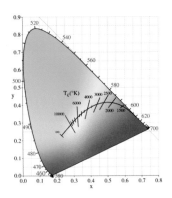

PLANCKIAN LOCUS
The color temperature scale plotted on a CIE 1931 x, y chromaticity space.

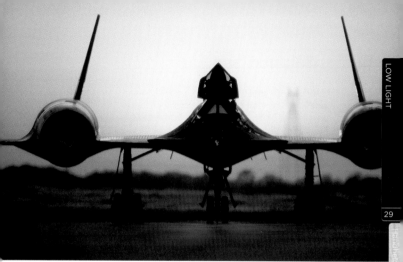

produces a redder light. Something burning at a higher temperature (few things on Earth practically, but a hotter star for example) will produce a light that is more blue. When most artificial lighting was incandescent—tungsten lamps—it made sense to use temperature as a color scale, from red through orange, amber, straw and white to increasing blue.

It makes less sense now that artificial lighting is increasingly dominated by fluorescent, vapor discharge and even LED lamps, but because photography has grown up using color temperature and Kelvin, these new light sources are made to fit into it the existing system. More accurately, they lie on a correlated color temperature scale.

The diagram shows what fits where. To be completely accurate, only incandescence really belongs on this scale, meaning the sun, an incandescent lamp such as tungsten or quartz-halogen, and a flame from a candle or a fireplace. Even the reddishness of the sun at sunset and sunrise, and the blue of the sky, are not strictly speaking on the scale, although

SUNLIGHT

Sunset colors are created by refraction and scattering, and here cover the apparent range from about 3500 K to less than 1500 K. The actual color temperature of the sun's disc is under 6000 K.

they appear to fit very well. They are caused by the scattering of short wavelengths of light. Fluorescent and vapor discharge lamps only just fit at best, as they emit light by very different means, and they certainly need additional hue correction. To say that a typical fluorescent lamp has a color temperature of 4200 K, as does my camera instruction manual, is quite misleading and only partly useful.

Beware of confusing the natural, visual way of describing this kind of color shift with the real color temperature scale. To the eye, the lower color temperatures associated with flames and sunsets are "warm," while the higher color temperatures that make evening skies and open shade look bluish are what most people call "cool."

White Balance and Hue

White balance in digital photography, as its name suggests, is the procedure for adjusting/correcting the overall color cast of lighting on a scene.

The principle is that by identifying areas that should be white in the image, then making adjustments so that they appear true white without a color cast, the color of the light falling on all other areas of the picture will also be neutralized. The obvious place to do this is in the camera as soon as the image has been captured, and this is practical because the color component of the image needs to be calculated in any case. As we saw on pages 22–23, the Raw capture is of tonal values only—effectively a monochrome image—and the color is sensed by filtering these values, pixel by pixel, through a mosaic of red, green, and blue. This mosaic, the Bayer array, has to be interpolated from neighboring pixels. It is relatively straightforward to bias this interpolation toward different color shifts. Naturally, this is more important in low light photography because of the wide range of possible light sources.

This could actually be done in any number of ways, but because photography has grown up with color temperature, this is the scale used in all cameras. However, as we just saw, many light sources lack a continuous spectrum, and technically they do not really fit onto the scale of color temperature as measured in degrees Kelvin. But, because color temperature is such a familiar and convenient concept, they are made to fit approximately. This explains, as we'll see on pages 44–51, why the camera menu choices for fluorescent lighting frequently appear not quite right. Most good digital cameras also offer some adjustment to each white balance choice. This can be to raise or lower the color temperature a little, or to shift the colors around the color circle slightly. Check the camera manual to familiarize yourself with the method used, as this varies by manufacturer.

Shooting Raw, which is recommended strongly for low light photography, makes the white balance set in the camera irrelevant, as you can choose the settings with absolutely no loss of quality on the computer during processing. Raw converters, of which there are many, give not only a scale of color temperature, but also of hue. This is basically a second color axis more or less perpendicular to the color temperature scale, and the two together give a huge amount of possibility when it comes to color adjustment.

Technically speaking, choosing the appropriate white balance setting for a particular image means neutralizing the color cast—making corrections so that it appears as if pure white light is falling across the entire scene. However, slavishly following this is not guaranteed to produce the most pleasing results. Not only are color casts not bad, they often contribute very much to the final color image.

White Balance dropper

A dropper allows the white balance to be set by choosing any tone that should be neutral (not necessarily white). There may be subtle, but noticeable, differences even between apparently similar neutral areas.

White Balance settings

The white balance settings in the camera menu and, for Raw images, in a Raw converter, adjust color temperature and hue. These four versions of white crockery set on a white Plexiglas display unit lit from beneath by unknown fluorescent lamps, were originally camera presets. They are, however, accessible and amendable in a Raw converter if the image was shot, as here, in Raw format.

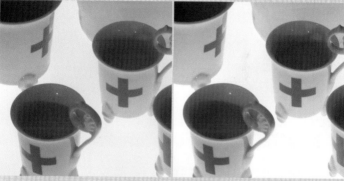

In-camera Auto

In-camera Fluorescent

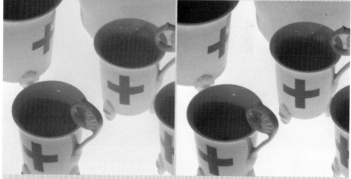

Lightroom Daylight preset

Lightroom White Balance Dropper

Key Camera Settings for Low Light

Cameras' menus vary widely, and use different terminology, but if you have a digital SLR to reasonable specifications, be conscious of all the following settings.

Image quality and format

The arguments for shooting Raw are stronger than ever in low light shooting, not least because it allows some latitude for recovering highlights and shadows, and allows you to defer decisions about color temperature until post-production.

White balance

The importance of this setting depends entirely on whether or not you shoot Raw. If you do, then it hardly matters what you set at the time of shooting, although most people prefer to have the image preview on the camera's LCD screen looking more or less correct. Opinions vary, but my default preference is Auto. If, on the other hand, you are shooting JPEG (with Raw for example), then constant attention to the choices in the White Balance menu is necessary.

Contrast

Low contrast is always safer, as it is easier to increase later in post-production than to recover lost highlights and shadows. Many low light situations feature high contrast, especially those with light sources in the frame. If shooting Raw, this does not matter, as contrast is applied after capture.

ISO sensitivity

This is likely to be the key control during low light shooting that you will access and change regularly. The flexibility offered by instantly switchable ISO settings is one of digital photography's biggest boons.

Long-Exposure Noise Reduction

Because Long-Exposure Noise Reduction is independent of the subject, in-camera processing is ideal. Check the camera manual, but choosing to set it to "on" will not affect shooting at normal shutter speeds. It will kick in at a specified exposure time; again, check the camera manual to see what this is for your model. At exposure times longer than this threshold, processing time doubles, because the automatic procedure involves creating a "dark frame" of the same exposure time, then subtracting the noise pattern in this from the previously exposed image. If you make a 30 second exposure, for example, you must wait another 30 seconds before you can shoot again. See page 174 for more details.

AUTO EXPOSURE BRACKETING
Adjusting the Auto Exposure Bracketing to the nearest third of a stop on a Canon menu.

LONG-EXPOSURE NR AND HIGH-ISO NR
Nikon menu offering both Long-Exposure Noise Reduction and High-ISO Noise Reduction options.

High-ISO Noise Reduction
High-ISO Noise Reduction works specifically on chrominance noise. It analyzes the image looking for small, near-pixel-sized areas of color that don't share the same color values as the larger surrounding areas. It then shifts the color values of the discolored areas so that they blend in with the background, so reducing chrominance noise without blurring detail. High-ISO Noise Reduction is only applied to JPEGs, although if you shoot Raw the file is tagged with the High-ISO Noise Reduction "marker" that will, when you convert the Raw file, inform the Raw editor to apply High-ISO Noise Reduction. However, you need to check that whichever Raw editor you're using can recognize the marker.

Bracketing
Some cameras offer auto bracketing, in which a burst of exposures gives frames under- and overexposed in addition to the metered exposure. This consumes storage space on the card and takes extra time when shooting, but if you feel uncertain about the exposure setting in some situations, it can be a useful backup (and you can always delete the unwanted exposures later if you need to).

Display choices
Because many low light scenes contain bright local lights and pools of light, it is useful to know when these are being overexposed. The most useful display for this is the highlight clipping warning, in which overexposed areas (where the photosites have filled up to their maximum values) are superimposed with a flashing warning. Some people find this distracting, but it is also valuable. A histogram is also particularly useful in low lighting situations, not least because the LCD screen image looks relatively brighter when the surrounding light is low. The danger of this is that if you judge exposure simply by this appearance, the image is likely to be underexposed. Viewing it on the LCD screen later in normal lighting is likely to deliver an unpleasant surprise.

AUTOMATIC ISO ADJUSTMENT
The Sony menu allows the user to set limits for the automatic ISO adjustment.

EXPOSURE WARNING
This screen simulates the clipping warnings that would be visible on screen as the shot is captured. The green area is the clipped highlight warning, but the remaining colors are displayed accurately.

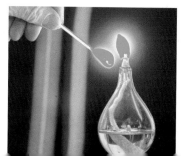

Natural Low Light

Low lighting conditions divide usually into those of daylight and those of artificial lighting. The normal maximum daylight is outdoors, in the middle of the day in clear weather.

As we've already seen, this is in the order of 50,000 lux or more. While it's probably going too far to say that the manufacturers of cameras, lenses, film, and sensors assume this to be the standard, what most people would call bright daylight is the ideal condition technically. This was the "sunny 16" rule, from the days when many photographers would estimate settings, and it holds that the

34

HABOOB

A sudden sandstorm, a variety known as a haboob in this Sudanese part of the eastern Sahara. Engulfed in a sand front, the light levels plunge and the neutral white balance of what was a bright, sunny afternoon, shifts to red.

usual exposure on a sunny day is 1 over the film/sensor speed at $f/16$ (thus 1/100 at $f/16$ at ISO 100).

What counts as low natural light sets in when it becomes difficult to guarantee sharp images with a normal lens and low ISO sensitivity. In practice, this means when it becomes difficult to either hold the camera steady, or freeze a normally moving subject at maximum aperture without taking special precautions such as fitting an unusually fast lens. There is no exact point, but this is somewhere around several hundred lux. Even during full daylight hours, thick cloud cover, rain, snow, and storms can reduce light levels to this low level. However, all we are talking about here are the technical difficulties as weather conditions such as these can deliver expressive imagery. Essentially, this is extreme diffusion,

CLOUDY DAWN
First light over an Andean town, with heavy weather and low clouds contributing to very low light levels (the building lights still dominate).

CLOUD FOREST
Stormy conditions at the summit of a volcano, typical enough in this area in Costa Rica to create a permanent cloud forest.

and so with cloud cover the color temperature is affected only a little. With something more unusual, like a sandstorm, the color can shift radically, as the example on the left illustrates.

Natural light levels are also reduced by shade of one kind or another. Woodland, in particular, furnishes these conditions, especially on a small scale, and when the sky is clear there is likely to be a significant color temperature shift (higher, therefore bluer) as the shade is illuminated by the blue sky. A more common kind of shade is indoors, when the illumination during daylight hours is usually through windows. The age and architectural style of the building, together

Locked Down

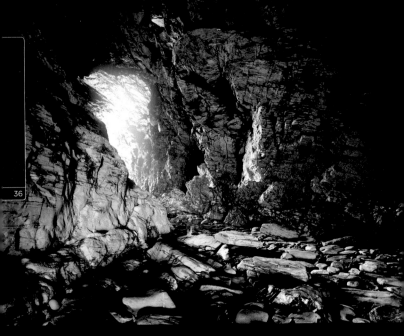

MERLIN'S CAVE

The legendary Merlin, teacher of King Arthur, is reputed to
have lived in this cave, under the Tintagel Castle which is
situated on the rugged north coast of Cornwall. The only
light source is that from the cave's entrance, so much of the
light falls across the surfaces near there at an extreme
angle, with the remainder stemming from a minimal
reflection from the dark rocks.

INDOOR LIGHT
This shot was taken in a well-lit artist's studio, but to capture it at $f/8$ nevertheless requires a shutter speed of 1/5 second.

ANSAR PRAYER
Friday prayer at the Ansar Mosque in Omdurman. It is lit unevenly through the windows, with the additional complication of a strong paint color that affects the color balance.

with the style of interior design, has a controlling influence here, but the major factor is the window area.

Outdoors, it is the ends of the day that create the main conditions for low light photography. Light changes quickly in both quantity and quality around sunrise and sunset, and while these two times of day may be indistinguishable to someone viewing the final photograph, they call for different shooting techniques to the middle of the day. The point at which the first and last sunlight of the day becomes a "low light" situation is highly variable, and generally hinges on the usual technical issues of shutter speed and aperture. Generally speaking, when you need to take precautions on camera shake and subject motion blur, you are taking a low light photograph. This depends on choice of subject, focal length of lens, and the depth of the scene, so becomes an issue when shooting away from the sun some time before it is for shots taken into the sun.

For photography, the two features that dominate this time of day are the sheer variety of lighting angle and the color. With the sun low in the sky, its light rakes horizontal surfaces, hence creating good textures on flat landscapes, and strikes vertical ones, like people and buildings,

from one side only. When you factor in the choice of camera viewpoint by moving around a scene, these times of day offer the greatest variety of lighting quality of any. Backlighting, frontal lighting, and all degrees of sidelighting are all there at one time. Above all, this is what makes the ends of the day so useful in photography.

Color also changes. For most of the day, the color temperature under a direct sun is a fairly constant 5200 K, or rather higher under cloud (up to around 6000 K). When the sun is close to the horizon, at around a 20-degree elevation or less, the color temperature falls, and the light becomes more yellow-to-red. This warm-looking color cast is caused by atmospheric scattering. Particles in the atmosphere scatter the higher energy, shorter wavelengths of sunlight, and as these are in the blue-to-violet end of the spectrum, what is left is more reddish. How red the light is depends on the composition of the atmosphere, as well as the amount of it the sun's rays are passing through. The sun appears at its reddest when right on the horizon because its rays are traveling through the greatest amount of low-altitude atmosphere. Expect between 3500 K and 4500 K on a fairly clear day.

Contrary to what many people expect,

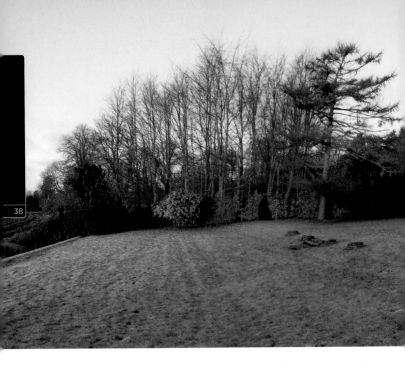

ENDS OF THE DAY

Although they may feel very different, thanks in no small part to the different physical temperatures, the photographic conditions are similar at sunrise and sunset. The ground frost, however, would certainly not be present in the evening.

there is no general distinction in the quality of light between sunrise and sunset. In either case, the sun is low and casts long shadows, and the color temperature is low. However, for every specific location there is a very large difference, and preparations made to shoot differ greatly. The aspect of any major subject obviously matters—which way it faces—and there may be a number of idiosyncratic things to consider. Local weather may change, as in morning mist or late afternoon haze. Activity in a scene is also often different. There also tend to be fewer people around in the early morning, and if this is summer in high to mid latitudes, sunrise is well before most people are even awake. This is a key consideration if

you want a view without people or traffic. In other words, to the viewer of a photograph taken with a low sun, there is no way of telling whether it was shot at the beginning or end of the day, other than by being familiar with the actual location. To the photographer, however, the distinction is extremely important for very local reasons.

Moving beyond the point when the sun is touching the horizon, dawn and dusk create special, shifting conditions that can often deliver lighting surprises. This is marvelous for exploration and also for adding image quality to scenes that might be mundane by day. When the sun is just below the horizon, there is a short period of faded light that may,

under the right conditions, offer a different and unusual quality of light to a scene. This is at either end of the day, and the length of twilight is no precise thing. It depends on the latitude and season, and is shortest in the tropics and longest in high latitudes because of the angle at which the sun rises and sets. As a rule, twilight works for photography when the sun is between the horizon (taken as 0) and about 15 degrees below. This is a rather shorter period of time than what most photographers would consider "golden light," when the sun is a little above the horizon. In any case, the cut-off point between twilight and night is a matter of personal judgment, and can depend on the weather.

FORMAL GARDEN AT DUSK

As dusk falls, the artificial lighting starts to compete with the natural light, which serves to add extra interest to this shot.

If the sky is completely overcast, twilight is irrelevant and indistinguishable—the light simply fades or brightens. If, however, the weather is mainly clear, the color and tonal effects in the sky itself can be very attractive. Twilight without clouds creates a vertical gradation of tone and color as at no other time of the day, and is strongest in appearance in the direction of the light. Depending on the atmospheric conditions, the number of hues in the sky varies. The scale might be from white to indigo, or from red through gray to blue. There is even the possibility of the "green flash," in which refraction of light in the atmosphere can momentarily color the tip of the sun green.

The most obvious use to make of twilight is as a backdrop to a silhouetted subject or sky-line, with the sky itself being, in effect, the main subject. In very clear weather, however, there may be enough color from the sky to give a delicate, ethereal illumination to the scene in the opposite direction. Delicate is in any case the keyword here. Good twilight is soft and unpredictable, and the changes in color and intensity tend to happen a lot faster than you notice.

There is also an important difference in the way that you see a scene as it moves into twilight. The retina has two different systems—photopic vision for bright light, with full color response, and scotopic vision for low light, with more sensitivity to light but poorer color distinction and resolution. The changeover from one to the other takes time. At the end of the day, the scene is getting darker, and the eye and brain take longer to adapt than in the opposite situation, when

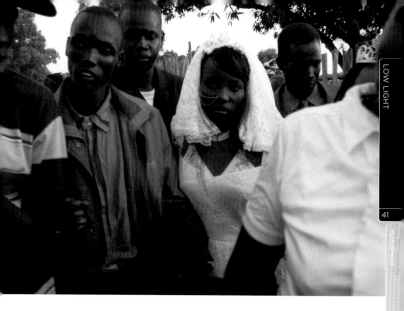

Locked Down

DUSK WEDDING

Captured at *f*/2.8, this dusk scene looks well lit though the chrominance noise is something of a give away.

the scene is getting lighter. This is partly due to familiarity, as fewer people experience daybreak than sunset, but the usual impression as night turns into day is that things are brighter than they really are. If you begin shooting so early in the morning that there is no light in the sky, just before sunrise everything will appear completely bright. Practically, it is important to keep checking the results on the camera's LCD screen, as your own visual judgment, particularly of color, may not be as reliable as you think. An important caveat here, as already mentioned earlier, is that at this time of day the preview image on the screen can be misleading in brightness. It, of course, stays at a constant brightness while the scene around it is either fading or brightening,

so it is very common to underexpose if you go by the screen image alone. At twilight, the screen's backlighting is much brighter than that of the surroundings, and this exaggerates the brightness of the image as shot, so always check the histogram as well.

Other than pure, natural landscapes, twilight also brings artificial lighting into play. After sunset, street lighting is switched on, as are interior lights in houses and offices, flood-lighting and display lighting. These may or may not be what you expect or want, and will often affect the composition. Lighting in cities tends to be different at each end of the day throughout the year. If you want the maximum amount of interior lighting visible in office blocks, for example, the best time is usually just after sunset in winter, when most people are still working.

True night photography is when there is not even a trace of residual light from the

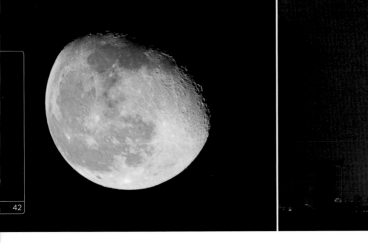

MOONLIGHT

The moon is 250,000 times dimmer than the sun, but is reflecting the same light.

sun, and this offers a few, limited possibilities (discounting astrophotography, which is a specialization too specific to deal with here). Mainly, night photography is practical when there is a clear moon and the phase is somewhere between half and full. This was both difficult and uncertain in the days of film, but digital technology has now opened this up to non-specialists.

The moon, of course, reflects sunlight, so for lighting purposes a full moon behaves like a very dim sun. A figure often quoted, and useful, is 250,000 times dimmer, which is 18 stops as a camera setting. Thus, to revive the "sunny 16" rule mentioned previously, the exposure for a high, full, unclouded moon would be 18 stops less than 1/100 sec at $f/16$ and ISO 100. This gives about 1 minute at $f/2.8$. This is a reasonable starting point for an "average" full-moon exposure, meaning

within a day or two of perfectly full (0-degree phase angle), within 15 degrees of directly overhead, and in clear air. Unlike film, sensors do not suffer from reciprocity failure, so this exposure needs no further adjustment.

In practice it is very difficult to judge the brightness of moonlight because it varies so much. There are several factors that affect this, and the phase is the most important. Between full and a quarter the brightness varies by an order of magnitude—about 3½ stops. The orbits of the earth around the sun and the moon around the earth also vary, so the sun distance changes by 7 percent and the moon distance by 30 percent, which combines to make a difference of about a third of a stop. The opposition effect, in which there is a sudden increase of brightness when the moon is just almost exactly opposite the sun, caused by the high reflectivity of the moon's surface, adds another third of a stop of variance. Finally, atmospheric attenuation because of moisture, dust, and the height of the moon above the horizon can make a difference of up to 8 f-stops (over 2 orders of magnitude).

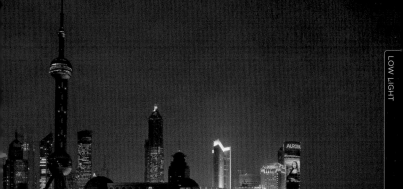

CITY LIGHTS

Pudong at night, seen across the Huangpu River from the Bund, Shanghai, China.

PURI

Moonlight and artificial light create contrasting colors in this image.

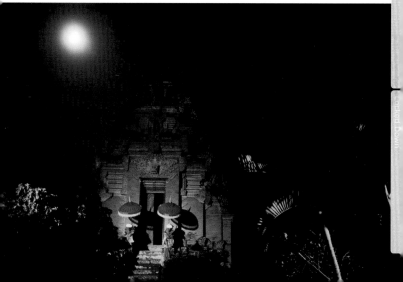

Handheld

Locked Down

Artificial Low Light

Lamps that work by burning filaments are the most traditional kind of artificial illumination, with a low color temperature but a continuous spectrum.

Specifically, the color temperature of a light source depends on the energy output (in watts), as we saw on pages 28–29, and is significantly orange in relation to daylight. Because incandescent lamps and the sun generate light by the same mechanism—burning—they are perfectly known quantities and are no problem for photography.

Non-incandescent lighting, however, is another matter, and is increasing in use. Most modern artificial lighting relies on the visible emissions from specific elements, which are always limited and never as pleasing as continuous-spectrum light. The development of lighting engineering has led to a growing variety of these non-incandescent lamps (another description often used is non-black-body lighting). All of them, from fluorescent to vapor-discharge lights, make use of specific chemical elements that are in one way or another excited to emit light. However, while incandescent light—from the sun to a flame—emits a continuous spectrum of wavelengths, individual chemical elements emit just a very narrow part of the spectrum. The emission spectra for these lamps have the appearance of a group of isolated narrow spikes. No single element on its own gives anything like the full spectrum of daylight, but by carefully choosing a group of elements it is possible to get close to its appearance to the human eye. This is mimicking a continuous light source, and how well it does this depends on the engineering design.

What matters to photographers is artificial light that is close to the quality of either sunlight or incandescent lamps, but this is only one of the aims of lighting designers. Other things may have a higher priority, such as efficiency, brightness, and cost. Ultimately, judgments about lighting are largely subjective, but in the lighting industry there are attempts to quantify it. One key concept is chromaticity, which is a measure of

TUNGSTEN HALOGEN
Downlighters used here in a modern Japanese tea-ceremony room are low-voltage (12v) tungsten halogen lamps. These burn brighter and hotter than standard incandescent lamps, and so at a slightly higher color temperature, and the low-voltage variety can be made smaller.

Tungsten vs fluorescent

The problem for interior photography, as shown in the main images here, becomes entirely understandable when the spectral power distribution is compared between tungsten (left) and fluorescent (at 5000 K, right). Not only is the red deficient, but more important, there are green spikes from the mercury.

2800 K INCANDESCENT HOUSE LAMP

5000 K FLUORESCENT
Notice the mercury energy spikes

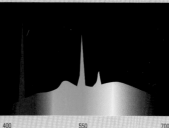

the quality of light as defined by its purity and dominant wavelength. Purity is akin to saturation and the wavelength is equivalent to hue. Both the CCT (Correlated Color Temperature) and the CIE x and y coordinates define this.

But because lighting that does not have a continuous spectrum is unlikely to be perfect in the way it renders all colors of all objects, another scale is needed, one that rates the lighting based on visual experience. The Color Rendering Index (CRI) is used by manufacturers to give an idea of how closely their products come to continuous lighting as perceived by viewers. It is based on a viewing test of eight pastel color swatches, which admittedly is not very many, and is one measure of metamerism (see the box on page 55). Both daylight and artificial incandescent light rate 100 on a scale from 0 to 100. The very best fluorescent lamps reach about 90, but poorer, cheaper ones can rate as low as 50, while some vapor-discharge lamps, such

DISPLAY WINDOW

Incandescent lamps behind a diffused screen at a restaurant. The diffusion spreads the fall-off in illumination around each lamp, and the apparent color. Overexposure near the center of each lamp records as close to white, shading to yellow and orange as it becomes darker.

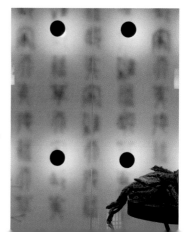

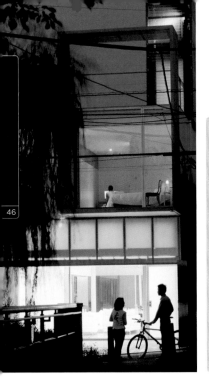

Quality of light

Light source	CRI
Sunlight	100
100 W incandescent lamp	100
Metal halide 5400 K	93
Deluxe pro warm white (Philips)	92
Deluxe cool white fluorescent	86
Metal halide 4200 K	83
Daylight fluorescent	76
Deluxe warm white fluorescent	73
Cool white fluorescent	65
Warm white fluorescent	55
White deluxe mercury	45
High pressure sodium	25
Clear mercury	17
Cow pressure sodium	0–18

Source: Illuminating Engineering Society. Interim Method of Measuring and Specifying Color Rendering of Light Sources, LM-19, NY, 1962.

FLUORESCENT IN CONTEXT
A compromise white balance for an evening shot that includes fluorescent lighting on the ground floor of this modern Japanese house, tungsten on the floors above, and a clear sky behind, reveals the essential greenness of typical fluorescent lighting.

as sodium, can be much lower still. Another view of the CRI is that it is a measure of how "pleasing" a light source is, and indeed this ultimately is what is important in most photography. All the settings and post-production work that goes into correcting images shot under fluorescent and vapor-discharge lighting is essentially concerned with making the results believable and pleasing. Fluorescent and the various flavors of vapor-discharge lamps differ considerably in the way they work, but for photography they present essentially the same (and considerable) problems.

Fluorescent light
Fluorescent lighting is spreading, particularly into homes and other spaces that were traditionally lit with tungsten. Concerns about energy conservation are encouraging this kind of conversion, and while photographically fluorescents are less predictable than

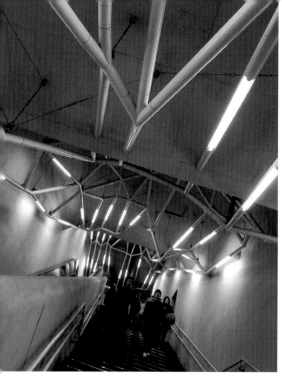

SUBWAY
A new Tokyo subway station uses fluorescent lighting as part of the design. With the view consisting of concrete walls and ceiling, Auto white balance is an easy and satisfactory solution.

incandescents, this is an inevitable process of change. Clearly, the ability to set the white balance in a digital camera makes all this manageable in a way that it was not with traditional film, but there are still issues.

Fluorescent lamps work by passing an electric current through a gas-filled glass envelope, typically a long circular tube (hence the popular name strip-lighting). The gas produces ultraviolet light that strikes the coating on the inside of the tube, which is a coating composed of a mixture of fluorescent compounds. These fluoresce (glow), for as long as they are bombarded with the ultraviolet light. The newest types have coiled tubes to make them suitable for replacing standard tungsten fixtures, and are known as CFL (Compact Fluorescent Lamps).

Because each of the fluorescents emits light in a very narrow band of the visible spectrum, the skill in designing these lamps lies in blending a range of them so as to approximate the full continuous spectrum that we are accustomed to from white or incandescent light. The key word, nevertheless, is "approximate," because there are always spikes, or gaps, or both in the emission spectra of fluorescent lamps. The

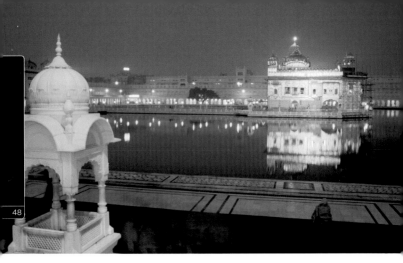

OUTDOOR VAPOR DISCHARGE

The foreground lighting in this night-time view of the Golden Temple, Amritsar, is vapor discharge. This strongly blue-green light, contrasts with the orange of the incandescent-lit Golden Temple itself, behind. In this instance, the color contrast helps the image.

ARTIST'S STUDIO

A Beijing artist's studio lit by multi-vapor lamps high in the ceiling. In this kind of situation, in which there is no other lighting for comparison, and in which the colors of the paintings need to be accurate (that is, grays neutral), aiming for a neutral white balance is the best option.

FLUORESCENT LIGHTING

This underground railway station platform is lit with Fluorescent lighting. In the far distance, it is apparent a different kind of lighting is used in the stairway.

Different lights, different colors

The problem of the sometimes strange cast from a broken spectrum can go beyond just the sensor's reaction. The eye also can receive different color information from that seen under daylight. Metamerism is when two color surfaces appear the same under one light (such as daylight) but different from each other under another light (as often happens with fluorescent lighting). This doubles the difficulty of judging how a scene should appear, and there is no obvious solution. Just be aware that some colors may shift independently of the majority.

human eye accommodates well to this slightly broken spectrum, and of course most of them are designed for human vision. The camera sensor, however, reveals any imperfections all too clearly. Fluorescent lamp design varies widely, not only on the scale of cool to warm (lamps tend to be classified as cool-white, warm-white and so on), but in the color casts they give that are not visible to the eye at the time. Even the high CRI scores given by manufacturers do not tell the entire story. The spectral energy distribution is not coherent and there will always be some discrepancies in yellow and green, as well as poor coverage in red and blue.

The important thing to remember is that in most photographs it is the appearance that counts. Occasionally, you may have a need for absolute accuracy, and there are ways of doing this (see page 50), but most of the time the color simply needs to look acceptable to someone viewing the finished image.

The white balance camera settings are the first point of control, essential if you are

shooting JPEG or TIFF, less so if you are shooting Raw. The difference is that with the first two formats, the camera will process the image and deliver a particular color balance as you shoot. With Raw, the white balance settings are kept separately from the Raw capture data, allowing you to choose which color temperature and hue/tint you prefer during post-production.

Clearly, as long as you don't mind spending extra time on the computer, Raw has the advantage. Nevertheless, even though any white balance can be chosen at this later stage, there are some advantages to choosing the best-looking white balance at the time of shooting. One is that it gives you an opportunity to check the result at the time by comparing the LCD screen with the scene. Admittedly, the camera screen does not give an ideally calibrated view, but it is better than nothing. The fluorescent settings (there may be more than one according to the model of camera) are the obvious choice, but as fluorescent color casts are unpredictable, they are not necessarily the best. Also consider using the auto setting, and varying the color adjustment if your camera has this. With more time available, set a custom white balance, although this can be a complicated procedure.

In any case, you must judge the way the color of the scene looks to you in some way, and this is especially important for Raw shooting. It often helps to remember a key color, and if there is a gray or other shade of neutral in the scene, this is worth noting. If you have time, one great help is to place a color target such as a ColorChecker in the scene and take a reference shot. Unless you need total accuracy, you do not need to perform a thorough profiling—simply being able to compare the target visually with the image is likely to be sufficient. You can also perform a basic balance by using the Gray Point dropper in Curves or Levels.

Vapor-discharge light

Now more widely used, vapor-discharge lamps are capable of high output and come in several flavors, the color depending largely on the type of gas. They share their basic principle with fluorescent lamps passing an electrical discharge through a gas. Here the gas contains metal vapor, which emits light, and Mercury is one of the principal components. The problem for photography is in the broken spectrum and emission spikes, and also in the shortage of long red wavelengths. The eye is less sensitive to the missing long red wavelengths than both film and sensors, and tends to accommodate the color output, seeing it as more or less white, while the sensor records it as more blue/green. In addition, red surfaces in a scene will tend to look darker and duller, again because of the deficiency in longer red wavelengths.

MIXED LIGHTING: WELDING
The temperature at the tip of a welding arc typically exceeds 6500 K, giving a bluish light when seen against the background of filtered daylight in this studio.

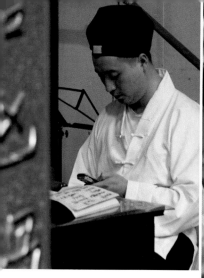

MIXED LIGHTING: DAYLIGHT AND INCANDESCENT

Daylight reflected from a courtyard, entering the scene from the right, contrasts with the incandescent lighting entering from the left. Their effect is very noticeable on the white clothing of this priest in a Shanghai temple. As in many other situations, two opposed lighting sources in one image has the potential to be attractive rather than a problem.

MIXED LIGHTING: MARKET

A street market in Kuala Lumpur contains a mix of daylight with 2800 K incandescent lamps hanging over each stall.

Fireworks

A few subjects reveal themselves in an image only by means of motion blur. One of the most obvious is a firework display. Even to the human eye, it is the rapid movement of points of light appearing as streaks that create the intended effect. A sharply frozen image taken at a short shutter speed would look like nothing more than bright points. Unless there is a significant amount of drifting smoke illuminated by the explosions, the shutter speed will have no significant effect on the overall brightness of the scene; instead, it determines the length of the streak in the frame. Generally, the longer the better, although it is usually sensible to keep one exposure to one burst of the display. The wider the angle of lens, the more certain you are of framing the display fully, but in any case, pay attention to the first burst for predicting the position of subsequent bursts in the sky. An alternative technique with a telephoto lens is to loosen the tripod head slightly, follow the rocket trail upwards, and when it reaches its highest point, quickly lock the head and open the shutter.

Color Temperature Blending

One fairly obvious method of handling a scene lit by different types of light source with opposing color balances is to treat it as two (or more) layers, one for each light source.

The principle is to concentrate first on color correction for each light-source layer at a time, and save the problem of combining them until later. Thus, for one image layer, you should focus entirely on only one light source, ignoring the effects this has on parts lit by any other source. For the next layer, do the same for the other light source. With three or more different light sources this can become unnecessarily complicated, but with two it is perfectly manageable.

The color adjustment method can be any of the ones discussed previously, including setting the Gray Point or White Point, applying a complementary overall color filter (Photo Filter in Photoshop), Hue/Saturation sliders, Color Balance sliders, and others. This depends very much on being able to identify which parts of the scene have been lit—and therefore color-shifted—by which light source, and this will be easier in some photographs than in others.

The next step is to blend the two (or more) layers in a sensible and realistic way. Again, Photoshop offers a huge variety of ways of doing this, but it is probably wise not to get obsessed with the relative merits of each method. In the end, we are dealing pragmatically with photographs. If the influence of each light source is clearly related to an obvious value, such as brightness, there is likely to be a procedure that can blend the layers simply. In the example here of the Japanese table detail, the brightness of the recessed glass lamp meant that incandescent lighting, at around 3000 K, affected most of the highlights in the scene, while the shadow areas

were for the most part lit by the much bluer evening daylight (around 6000 K). This made a procedural blend an easy choice, using some trial and error with the Blending Options from the Layers palette, and settling on Soft Light.

Blending options

A glass artwork set in a table and lit from beneath. Photographing it at dusk gives a choice of two very different color temperatures. Fortunately, most of the incandescent lighting is at the high end of the tonal range, giving the opportunity to blend the two images as layers, selecting the blend on the basis of brightness (orangier version underneath).

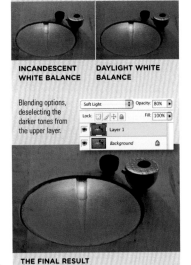

INCANDESCENT WHITE BALANCE

DAYLIGHT WHITE BALANCE

Blending options, deselecting the darker tones from the upper layer.

THE FINAL RESULT

Blending options

A different approach to the same problem. Daylight entering from the small window contrasts sharply and not very pleasantly with the incandescent lighting of this bathroom.

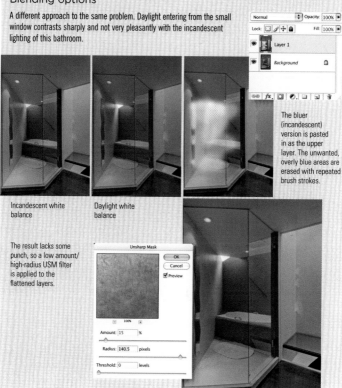

The bluer (incandescent) version is pasted in as the upper layer. The unwanted, overly blue areas are erased with repeated brush strokes.

Incandescent white balance

Daylight white balance

The result lacks some punch, so a low amount/high-radius USM filter is applied to the flattened layers.

Unsharp Mask

OK
Cancel
☑ Preview

100%

Amount: 15 %

Radius: 140.5 pixels

Threshold: 0 levels

Otherwise, a hands-on approach using erasing or brushing, allows more personal choices. One obvious choice is to erase the "wrongly lit" areas from the upper layer, paying careful attention to the size, opacity percentage, and hardness of the brush. Another is to use the History Brush. In this case, one method is to make the necessary color adjustments to one image, add another layer with its own, different adjustments, flatten the image, and use the History Brush tool to restore selectively from the original. This is more complicated to set up, but some people find restoring more intuitive than erasing. If you are using brushes in any of these ways, make sure that the number of History States is set high enough in Preferences before you start.

Selective Color Change

A direct approach to the problem of mixed light sources is to select the color effect of one and then shift it or filter it toward a more pleasing or neutral result.

There are a number of ways of targeting specific colors in an image, and these vary according to the image-editing software, and whether you're working on a Raw file, converted JPEG, or TIFF. If you're working on converted files, beginning with Photoshop, the two most convenient are Replace Color (see box, page 57) and Hue/Saturation, both found under *Image > Adjustments*. Hue/Saturation has been around for a long time, and Replace Color is actually a more focused version of the procedure, with an added preview of the areas selected. In either case, the technique involves first selecting the most intense area of the offending color, and adjusting the range of the selection. The three parameter sliders Hue, Saturation, and Lightness can then be adjusted to taste. In Hue/Saturation, once you have selected a color range from the drop-down menu, clicking on part of the image will refine that selection. A third procedure that is less intuitive is Selective Color, also under *Image > Adjustments*.

There are two possible drawbacks to these otherwise excellent and easy techniques. One is that the choice of color alteration is not fully flexible. It relies on Hue shift by degree, Saturation, and Lightness, and misses out on arbitrary color filtering (such as Photo Filter, also under *Image > Adjustments*) and contrast control. The other drawback is when a targeted color also covers other objects and surfaces in an image that you do not want to change. In the latter case, for example, imagine a blue vase in an interior view lit by both incandescent light and daylight. If you decide to select the blue cast from daylight and shift that, the same effect will happen to the vase. A sensible and manageable solution is to use the History brush to restore those areas.

A more laborious, but potentially more accurate, method of selection is to define the areas of the image that you want to change. There are several ways of doing this, including such selection tools as the Magic Wand, Quick Selection tool, or Color Range feature to name a few. These create selections that can then be modified by expanding, contracting, selecting similar values, and so on. Alternatively, there is direct mask painting, which can then be used as a selection. Often, selection is more accurate by using a combination of these methods; for instance a quick selection by first using the Magic Wand, converting this into a mask, then modifying by erasing and painting, and possibly blurring.

Increasingly Raw conversion software, such as Apple Aperture and Adobe Lightroom, allows for basic selections to be made. This makes it possible to amend localized regions of an image, such as a selective color change. Another example of Raw conversion software, DxO Optics Pro, features a Multi-Point Color Balance tool that negates the need for selection by allowing the user to shift several points while viewing a preview on the right of the screen (see box, right). All these Raw converters make non-destructive editing much more easily accessible to photographers who have become used to the many tools in "pixel" image editors (such as Adobe Photoshop) which act on specific areas of an image. And because you're working on unprocessed 12- or 14-bit Raw data, the results will have fewer artifacts.

DxO

Color balancing in DxO Optics Pro, called Multi-Point Color balance, allows several points to be clicked, and then the color shift specified by dragging around a color wheel.

The image as opened in DxO, original on the left, changes applied on the right. This is the default, with some automatic corrections.

The first point is in the shaft of light, which I want to be neutral. Note that sampling very bright tones can create huge shifts in the rest of the range, but this will be taken care of in the next sample.

The second sample is in the water, which I want to make more vivid. The third and final sample is on the stalactites at right, which are too red because of the incandescent lighting.

Lightroom

In Lightroom we can make a selection and apply a localized color change.

Compared with the daylight illuminating the near ceiling tiles, the farthest part of the room appears too "hot."

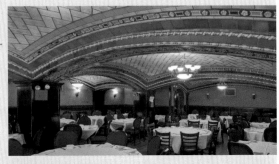

Using Lightroom's Adjustment Brush and its associated sliders, a selection is quickly made of the offending area. Here we've selected Color mode.

Selecting a light blue to "paint" over the reddish cast provides a more balanced result.

Photoshop Replace Color

Photoshop's Replace Color tool replaces areas of color without selecting them separately.

Original

The exact sample points are critical. Red dots mark the points sampled, and show the importance of finding the point that encompasses the entire area that we want to shift.

With the precise sampling point finalized, the hue is lowered slightly, as is the saturation, and the lightness increased, all to match the rest of the steps.

The result judged a little too yellow.

Using Selective Color, the yellows are chosen, and their precise hue manipulated for a more neutral, creamier effect.

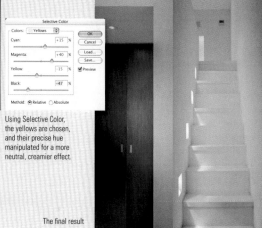

The final result

HANDHELD

As I mentioned at the beginning of this book, one of the outstanding practical features of low light photography is that you are always pushing the limits. And these are, first and foremost, technical limits, with a clear, smoothly toned image being the reference standard.

The goal is almost always to reach the best possible balance between sharpness and noise. Sharpness, as we're about to see in this chapter, is a huge area of importance and covers much more than most people might imagine. This is why I plan to devote many pages to it, because in low light photography more than most kinds, an essential skill is to be able to judge sharpness and unsharpness to a particularly fine degree.

In practice, setting out for a low light shoot requires a key decision—whether or not to use a tripod. On the face of it this may sound a little trivial, but it has far-reaching consequences. The two paths, handheld or tripod shooting, are each suited to different subjects and conditions, and they are widely divergent in style. They also depend on a decision before planning the photography, because unless you are fortunate enough to have an assistant or a willing companion to carry things, what you set out with in your camera bag and on your shoulder will determine the kind of photography you can do.

In this chapter, I want to look at the tripod-free approach, relying on hand-holding skills to get as close to normal, rapid-reaction, reportage photography as possible. Here, your own physical skills become important, especially how steadily and reliably you can hold and operate the camera. Professionals take some pride in doing this, but they are by no means immune to failure, precisely because they are pushing limits. One thing that low light photographers quickly get used to when shooting without rock-steady support is there is always a failure rate. Of x number of frames shot, y will be flawed because of blur of one kind or another. The aim is to bring the number y down as much as possible, and reduce the proportion of failures. Indeed, if every frame were technically perfect, this would be a sign that you were not pushing the limits as hard as you could.

TOWARD THE LIGHT

Making the most of what little light there is is essential when shooting handheld. Here shooting toward the light created dramatic silhouettes of these U.S. warplanes.

Handheld or Locked Down

Low light photography is one area in which process dominates. By this I mean that all the various limits and difficulties that we looked at in the first chapter need to be thought about before you start shooting.

In practical terms, low light shooting is about pushing technical and mechanical limits as far as you can, and this in turn means that there are two competing ways of approaching it. In one—the subject of this chapter—the idea is to do everything necessary to retain the freedom of using a camera in much the same way as you would under normal light. The alternative is to abandon freedom in favor of a full choice of technical settings—sharp, clean images without noise, and at any aperture setting, and with no limit to the exposure time (except, of course, for short exposures).

It is not easy to switch from one to the other mid-shoot, so it is normal to decide at the start which route you are going to take for any one session. There are good arguments for both handheld and for using a tripod, and which to choose depends on the subject, your preferred style, the results you are looking for and the quality you absolutely need. The last factor is too often ignored, as we'll come to in

SUBJECT MOTION SETS LIMITS

Handheld shooting reaches its practical limit when the movement of subjects is too fast even for a combination of wide-open aperture and high ISO setting. This is a tripod shot at 1/10 sec, making deliberate use of the blur of a passerby.

LOW LIGHT REPORTAGE

Shooting handheld means being able to follow classic reportage methods, which include quick observation and photographing unnoticed. The difference is the lower light levels. Here, at a museum in Shanghai, bracing against a wall allowed a shutter speed of 1/4 sec with a 33mm EFL, and a low ISO setting of 100.

SIZE MATTERS

While noise is evident at 100% magnification on the computer screen, in print and at this size of reproduction, it becomes unnoticeable. Size of use is always an important consideration.

DETAIL

Remember to use the 100% magnification to check pixel-level detail.

HANDHELD MOVEMENT
Handheld shooting allows for a number of loose, ad hoc effects, such as a slow speed while walking, as in this image, taken at 1/3 sec.

a moment, and can sometimes make the others redundant.

The key factor for most photographers is the optimum shutter speed for subject movement. If the subject is active, for instance people in motion, a tripod is no help in freezing the movement. Some kinds of movement may well be acceptable, or even desirable, such as the streaked trails of vehicle lights on a highway, but if you need sharp capture, the threshold shutter speed for this determines everything. This in turn is affected by the relative movement in the image frame (see pages 110–113), so a walking figure naturally calls for a faster shutter speed if it fills the frame than if it takes up just a small part of the picture. But basically, the rule is, if you are photographing people, then shoot handheld.

The obvious advantages are freedom and mobility, and the chance to shoot unobserved, without drawing attention to the camera as is inevitable with a tripod. You can strip down the amount of equipment drastically; one camera, one or two lenses, maybe a flash unit if the camera does not have one built in, and very little else. Gone are the days of two camera bodies, each for a different film (such as high-speed color, with high-speed black and white to be pushed to the maximum if necessary). Digitally, everything can be dialed up from the menu.

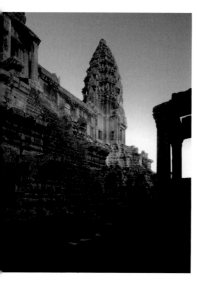

Handheld vs Locked Down

Handheld
- Free, quick, and mobile
- Unobtrusive, allows reportage-style shooting
- Lightweight, needs little equipment
- First choice for subjects in motion
- Camera shake always an issue
- Fast lenses are a priority
- Needs high ISO settings, resulting in noise
- Depth of field always shallow because wide apertures used

Locked down
- Static, takes time to change viewpoint
- Conspicuous, may attract unwanted attention
- Tripod can be an inconvenient burden
- First choice for static subjects
- If tripod used well, no risk of camera shake
- Any lens can be used, even very long slow telephotos
- Can use lowest ISO setting. Good depth of field practical by stopping down

DEPTH OF DETAIL
Images that rely heavily on fine resolution of detail, and which are likely to be used large, such as this formal architectural view of Angkor Wat, call for maximum image quality. Noise artifacts are especially unwelcome, so a tripod is the natural choice.

The disadvantages are in camera handling and image quality. As handheld shooting in these conditions almost never enjoys the luxury of fast shutter speeds, holding the camera (and yourself) still is always an issue, and may often—as we'll see a few pages further on—call for over-shooting to lessen the risk of frames lost to camera shake. A fast lens, with a maximum aperture wider then $f/2$, is a distinct advantage, though costly. Image quality centers on noise, because the key strategy is setting the appropriate ISO. High sensitivity means high noise levels, and while there are ways of dealing with this it reduces quality. This completely depends on how the pictures are going to be used, in particular the size. It is very important to become familiar with just how bad different noise levels look when reproduced at particular scales. The positive side of this is that if you are going to use the picture small, the noise may be invisible, thus giving handheld almost no disadvantages at all.

Steadying Techniques

The ability to hold a camera steady tends to be assumed, and the general opinion is that you either can or cannot. In fact, it can always be improved by following certain techniques and by training yourself in specific ways.

In normal lighting and with standard camera settings, this is rarely an issue, as shutter speeds of at least 1/125 sec are usually possible. When the shutter speed needs to be longer, as in 1/30 sec, 1/15 sec and slower, camera shake becomes a pressing problem. At worst, you lose shots, while at best you waste time checking the image after each shot to confirm that it is sharp. Low light photography, with its typically slow shutter speeds, is when you most need to be able to hold a camera steadily enough to remain on the subject.

On pages 84 to 91 we'll look in detail at what happens to the image under the influence of camera shake, but the issue is whether the image moves sufficiently in the time allowed for the exposure to be noticeable. This boils down to the speed of the twitch or jitter, which determines what distance the image jerks across the frame. An important secondary factor is the focal length of the lens. A longer focal length magnifies the image more, and this magnifies any movements, including camera shake. A widely accepted standard is that camera shake is unlikely at a shutter speed that is the reciprocal of the focal length, because most people can hold steady at such a speed. Thus 1/100 sec with a 100mm lens should carry no risk.

These are reasonable and slightly conservative estimates, but any serious photographer should aim to improve on them, provided you do not suffer from any condition which makes it impossible. When seeking that improvement, it makes sense to turn to activities that rely totally on holding a piece of equipment steady against a distant

Movement and focal length

The amount of movement revealed by camera shake depends on the magnification, and so is proportionate to the focal length. These are the relative movements of the same amount of shake at three different focal lengths. Wide-angle shots suffer the least of all.

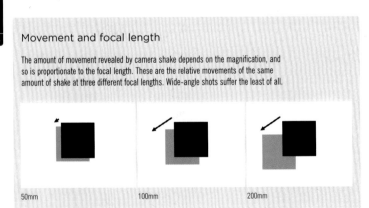

50mm

100mm

200mm

SLIGHT MOTION BLUR

SIGNIFICANT MOTION BLUR

EXTREME MOTION BLUR

EXTREMELY SHARP

ACCEPTABLY SHARP

Testing yourself

Examine the results in an image browser or image database, ideally at 100 percent magnification and in small groups side by side. The results shown here are my own, created just as described. As I would have hoped after all these years, I can hold a camera steady at the reciprocal of the focal length, and that's practice and experience more than anything else. It could still do with some improvement, and it occurred to me that I haven't been following my own advice as much as I could. Nevertheless, that's my benchmark, the speed at which I would expect to get every frame sharp. Slower than this, however, the figures become more complicated. Here, it's useful to grade the degree of sharpness. Exact measurements, such as pixel smear, are irrelevant, as sharpness is ultimately perceptual. You do need to use your own judgment. I find the following categories, which are entirely personal, to be useful:

- Extremely sharp
- Significant motion blur
- Acceptably sharp
- Extreme motion blur
- Slight motion blur

The results are shown in Table 1. On the face of it, there seems to be a reasonably clear separation, with the results from the three slowest shutter speeds quite useless. However, the interesting speed is the one immediately below my benchmark speed, where one of the three was acceptable.

So, on to the next stage of the test; to get a better sampling by shooting more frames in quick succession I took 20 consecutive frames at my benchmark speed, 1/focal length, or in the case of this 85mm lens, 1/80 sec. The result was that only a third of the frames were perfectly sharp, just over a half were acceptable, and a few were blurred. I followed this with another 20, at 2/focal length, or 1/40 sec, and finally 20 at 4/focal length, or 1/20 sec. The results in Table 2 show that there is no sharp dividing line between the lowest reliable shutter speed and the ones afflicted by shake. Instead, at the speeds below the benchmark, there is a percentage success rate. Moreover, even 1/20 sec, which would be foolhardy to try with any expectations, actually did deliver two acceptable frames out of 20. What we can learn from all this is first that over-shooting at certain speeds increases the probability of a sharp, usable frame; and second that the goal of training and practice is not just to improve your slowest reliable speed, but to improve the percentage success rate at all speeds.

How to improve these figures? First you need to know exactly what you are trying to correct and improve. Although this is a personal interpretation, four things cause camera shake, and each calls for different corrective techniques. These are drift, shaking, twitching, and jerking the shutter release. The first is a relatively slow movement around the subject caused mainly by the difficulty of

Test procedure (100mm focal length)

This table indicates the camera settings you should shoot test frames at.

Reference frame	Basic standard	1 stop over standard	2 stops over standard	3 stops over standard	4 stops over standard
1/2 focal length	1/focal length	2/focal length	4/focal length	8/focal length	16/focal length
e.g. 1/200 sec	e.g. 1/100 sec	e.g. 1/50 sec	e.g. 1/25 sec	e.g. 1/12 sec	e.g. 1/6 sec
3 frames	3 frames	3 frames	3 frames	3 frames	3 frames

Table 1 (85mm lens handheld, 3 frames each speed)

	1/160 sec	1/80 sec	1/40 sec	1/20 sec	1/10 sec	1/5 sec
Extremely sharp	3	3				
Acceptably sharp			1			
Slight motion blur			2			
Significant motion blur				1	1	
Extreme motion blur				2	2	3

concentrating absolutely on one thing for a period of time, and is entirely natural. However, it becomes important in photography only when some precise alignment needs to be made, such as the edge of a subject very close to the frame edge. Shaking is connected to heart rate, breathlessness, and the general level of nervous energy. This is promoted by adrenalin, so being excited about a shot you are about to take is unhelpful, even though difficult to control. Twitching is also related to nervous energy, but is a much more distinct and jerking movement caused by muscle contraction. In the context of aiming at a target it is more likely to be semi-voluntary than involuntary. Semi-voluntary means that you are conscious that it is about to happen because your brain is about to trigger the response, but that the tension caused by thinking about it, and by thinking about holding steady in general, seems to make it happen anyway. Finally, pressing down too hard on the shutter release does what you might expect, when all that is needed is a gentle squeeze.

People vary in how much they are prone to each of these, for physiological as well as psychological reasons. Drift is the least problematic, and can usually be solved by full concentration and by not trying to hold the subject in the viewfinder for too long. As for the minor tremors of shaking, some people are by nature calmer and steadier than others, but ways of improving this include any number of ways of relaxing and slowing the heart rate, such as by deep breathing. Taking a deep breath, then slowly and steadily exhaling, and squeezing the shutter release at the end of this cycle is one reliable technique. Another is to move onto a subject by either raising or lowering the camera, in order to take advantage of the steadying effect of motion. Twitches perversely tend to increase or are encouraged by the tension of trying to hold steady. One answer is to time the shot between two twitches, another is to raise the camera and shoot with as little delay as possible, trading accuracy in composition for steadiness. As you can see, there are a number of different approaches, and people tend to choose the one that suits their personality best.

Table 2 (85mm lens handheld, 20 frames each speed)

	1/80 sec	1/40 sec	1/20 sec
Extremely sharp	6	2	
Acceptably sharp	11	3	2
Slight motion blur	3	7	4
Significant motion blur		8	5
Extreme motion blur			9

object. There is much to learn from rifle shooting and from archery, where there is a rich history of training and practice in aiming and hitting targets. In photography, locking onto the "target" is only one step in the complex process of making an image, but in low light it becomes especially important.

The first step is to know what you are capable of, and the way to do this, as well as to improve and train, is a kind of target practice. Photographing meaningless subjects may be anathema to many people, but frankly it is better to test your hand-holding abilities when the results do not matter. As always, it is best to avoid on-the-job training. Take a stationary subject that is convenient, at an easily focusable distance, and which has good sharp detail. Printed type is good, as in an optician's. Make this a test that is practical for your own way of shooting, so assemble the lenses you normally use. If a zoom, decide on certain focal lengths, such as both ends of the scale and two or three points between, depending on the zoom range. Set the camera to shutter priority. Take a series of identically framed shots at one focal length. Begin a shutter speed high enough to guarantee sharpness—for instance, twice that of the reciprocal of the focal length, as 1/200 sec with a 100mm lens. This will be the reference. Then set the shutter speed to half as fast and take three shots. Adjust the shutter speed to half as fast again and take three more shots. Follow the steps shown in the Test Procedure table (see page 66). The reason for shooting three frames for each setting is that camera shake is unpredictable.

Holding the camera

VARIOUS HAND POSITIONS

The hand positions illustrated here are aimed to maximize the steadiness of the camera while still leaving access to the controls unfettered. The latter can be especially important in rapidly changing conditions.

HORIZONTAL GRIP

The weight of the camera is distributed equally between the hands.

STANCE

As important to a low light photographer as to a marksman or archer, body and arm position is critical. If possible, use any available support.

AD HOC SUPPORTS & TELEPHOTOS

Rigidity is more important with a long-focus lens than with any other. Not only is the image magnified, but also the shake, as illustrated on page 65.

NO SUPPORT

The weight rests on both elbows. Place left hand far forward.

AVAILABLE SUPPORT

A camera bag or other object gives a three-point support.

HORIZONTAL GRIP, SIDE VIEW

Press both elbows into your chest to improve steadiness.

BATTERY GRIP, HORIZONTAL

Use the additional grip on the battery attachment if there is one.

VERTICAL GRIP

The left hand takes the weight of the camera.

BATTERY PACK, VERTICAL

Bulky battery packs are more difficult to use vertically. Take more weight in right hand.

STANDING POSTURE

Spread your weight between both feet, and place one slightly in front of the other.

KNEELING

This is a more stable solution than standing, but less convenient. Rest on your heel and support your left elbow on your knee.

SQUATTING

In this position you can form a camera platform with your body. Rest your elbows on your knees and lean forward, forming a compact, relaxed structure.

UNDERHAND

Press your left elbow firmly into your chest, supporting the lens weight from below.

UNDERHAND, BATTERY GRIP

The weight is supported by the left hand and leg, the right is free to operate camera.

AVAILABLE SUPPORT

If possible, use any available surface to support the camera. A camera bag can often add extra height or padding.

Steadying Equipment

The idea of handheld shooting, as just discussed, is the freedom to do without a tripod, with its added bulk and weight, and slow setup.

Nevertheless, just as the camera can quickly be steadied against a part of the body, there are various supports, mostly small, that can be brought into use quickly and easily without compromising the freedom to move and shoot. The trade-off between stability on the one hand and lightness and ease of setting up on the other is here skewed heavily toward the latter.

One of the disadvantages of all mounts in this kind of shooting is the time it takes to attach the camera (or lens) and some kind of quick-release plate is important. An L-shaped plate, as shown opposite, allows the camera to be mounted for vertical as well as horizontal format, and when speed is essential this scores strongly over plates that attach the base of the camera only.

Monopods are a long-established design of fast support, and can be used either free-standing for an improvement in the order of a couple of stops, or wedged or propped against something solid for more stability. A ball-and-socket head, which can be used slightly loosened, is probably the most useful mount.

Miniature tripods, also known as mini-pods, have the advantage of being small enough to fit into the side pocket of a shoulder bag, or even a pants pocket. There are several ingenious designs and this kind of tripod works well braced against a wall or any vertical surface, and when the legs are folded together it can also be used as a hand grip.

The camera can be further steadied by applying either compression or tension. Compression typically means pressing the camera against a surface or a part of the body, and this is effective also with a mini-tripod. Miniature supports like this are light in weight and resist torque poorly, so if the camera is left more or less free on the mount, it is quite likely to suffer some camera shake from mirror slap. We'll go into this in more detail when we look at regular tripods on pages 142–144. Pressing down on the camera with one hand, or even placing a jacket or shoulder bag on it, improves steadiness. Without a miniature support, an important precaution when resting the camera on a hard surface is to place something slightly soft underneath—a piece of clothing, for example. This will dampen any vibrations from your body or from the mirror.

Tension is the opposite of compression, and equally effective, although it is a little more difficult to put into practice. Essentially, tension needs a strap of some kind. The tension strap works like a monopod in reverse: one foot secures the base of the strap while you pull the camera upwards to steady it. Even the regular camera strap can be put to use, by placing it against something solid and then leaning backwards to make taut the strap. This means first composing and then shooting briefly blind, but works if the camera is placed between railings, for example. In all of this, some improvisation is called for.

Kit bag

Depending on the situation, there are a number of tools you can call upon to steady your shooting.

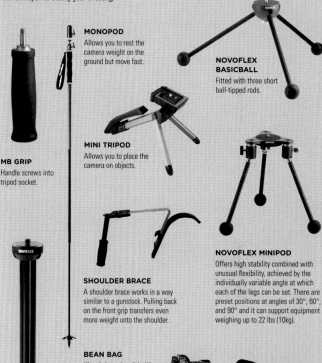

MONOPOD

Allows you to rest the camera weight on the ground but move fast.

NOVOFLEX BASICBALL

Fitted with three short ball-tipped rods.

MINI TRIPOD

Allows you to place the camera on objects.

MB GRIP

Handle screws into tripod socket.

NOVOFLEX MINIPOD

Offers high stability combined with unusual flexibility, achieved by the individually variable angle at which each of the legs can be set. There are preset positions at angles of 30°, 60°, and 90° and it can support equipment weighing up to 22 lbs (10kg).

SHOULDER BRACE

A shoulder brace works in a way similar to a gunstock. Pulling back on the front grip transfers even more weight onto the shoulder.

BEAN BAG

Kinesis bean bag "shell" filled with either 2.7kg of polyethylene beads or 0.7kg of buckwheat. With two compartments it can be folded for additional height, as shown.

MICROPOD

Small tripod for lightweight cameras.

Stabilizing Technology

Under the names Image Stabilization (Canon) and Vibration Reduction (Nikon), this lens technology, invented in the mid-nineties, is spectacularly useful in low light photography.

The basic principle is straightforward, the execution less so. Camera shake—that is the inability to hold the image steady at slow speeds—results in the focused image moving rapidly on a plane perpendicular to the camera axis. If the lens, or one of its elements, can be made to move in exactly the opposite direction to the shake, the image will be stabilized.

In practice, the special lens is equipped with sensors that can detect the movement, and a microprocessor to analyze it and transmit the necessary information to micromotors. The Nikon VR system, for which there is more published information available, is contained in a unit that contains a floating lens element within the lens assembly. Handheld camera shake takes place on two axes, pitch (up and down) and yaw (side to side), also known as the x and y axes respectively (the z axis, roll, is irrelevant here). Two angular velocity sensors, one for each axis, detect movement and are sampled every 1/1000 second. This data is sent to a microcomputer built into the lens, and from their combined reading, the angular velocity is known for any direction across the plane. The microcomputer calculates the compensation needed in direction and strength, and transmits this to two voice coil motors, one to move the lens element horizontally, the other vertically. (Voice coil motors, or VCM, were originally developed for speaker systems and are wire coils used to move a component back and forth within a magnetic field.) Working together, and controlled by the electric current within the

unit's magnetic field, they compensate for any motion in the vertical plane.

In most cases, the system is activated by lightly pressing the shutter release. As the shutter is pressed for shooting, the motors engage and the viewfinder image jitters as the compensatory movements are made. In the Nikon system, the floating element is centered immediately before exposure so as to allow the most efficient compensation. Canon and

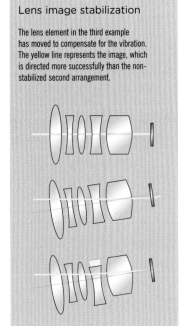

Lens image stabilization

The lens element in the third example has moved to compensate for the vibration. The yellow line represents the image, which is directed more successfully than the non-stabilized second arrangement.

MOVING SENSOR STABILIZATION
This is the "SteadyShot INSIDE" mechanism featured in the Sony α900, which moves the sensor to compensate for camera shake; it provides up to 4-stop blur reduction.

Nikon systems vary in how and when this compensation is displayed, and while many photographers find the jittering distracting, it gives a valuable indication of when the compensation has been fully made (the jittering stops). Added sophistications are algorithms for when the camera is mounted on a tripod (camera shake can happen at shutter speeds from around 1/30 sec to half a second because of mirror slap on an SLR) and for deliberate panning. Panning recognition works by sensing gross horizontal movements and discounting them.

The improvements over non-stabilized handholding are in the order of 3 to 5 stops, and the greatest benefit is at longer focal lengths. This does, however, depend on the photographer's success at holding a camera steady in the first place. Nikon studies with a 200mm lens show that a photographer who can achieve a 70 percent success rate unstabilized at 1/125 sec can expect the same results stabilized at 1/15 sec. Stabilized lenses demand power, although the systems contain

STABILIZING LENSES
Canon build image-stabilization technology into some of their lenses, such as this 17–85mm zoom lens. The Image Stabilizer branding is clearly visible on the lens barrel.

means to conserve this. Tests show an average draw of 80 microamps when activated (but not functioning), which is four times that of a digital SLR without stabilization.

Sony, Pentax, and Olympus employ a different approach (albeit applied in slightly different ways), in which the sensor moves to compensate for the shake. The sensor is mounted on a movable platform that can be shifted in the x and y axes by actuators. The considerable advantage of this is that it works with all lenses, and an improvement of between 2.5 and 4 f-stops is claimed. There are disadvantages, however, one being that the effect isn't obvious through the viewfinder as the lens is not involved, meaning that you see no compensating judder or inertia, although an indicator in the viewfinder shows that the system is functioning.

Fast Lenses

Prime lenses (that is, those with a fixed focal length) used to be the standard for professional photography, until their status was gradually eroded by zoom lenses with excellent optical qualities and remarkable zoom ranges.

Yet one of the advantages of prime lenses is that they can be designed with very wide maximum apertures. This is not new technology. Ultra-fast lenses have been around for a while, from the early Ermanox from 1924 with its Emostar $f/1.8$ (not great by today's standards but remarkable then) to the Leica Noctilux-M 50mm $f/0.95$ lens of today. Extremely high resolution is a necessity, because, as we'll see on the following pages, a large maximum aperture results in shallow depth of field, and this usually concentrates the focus on a tiny area, making its definition all the more crucial. The main problem for most people is the cost; good, fast primes are very expensive. Other issues are that they tend to be relatively bulky and heavy, a consequence of all that extra glass, and many, surprisingly, have manual rather than automatic focus. The decision to invest in a fast lens for low light shooting largely rests on how much of this kind of photography you intend to do. The performance advantage, however, can be considerable. Of course, unlike film photography, where the bottom line was the amount of light entering through the lens, digital shooting allows quick changes to the ISO. Nevertheless, a fast lens allows you to hold off the moment at which you dial up the sensitivity and start to lose image quality to noise.

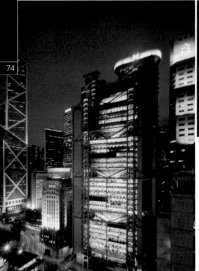

SAGITTAL COMA

This disturbing blur shape, noticeable in sharp focus and even more so with soft focus, is a distortion effect that fast lenses are computed to avoid. The example here is particularly bad, with a slow wide-angle lens at close to full aperture—$f/5.6$. Note that the coma "points" toward the center of the lens and is at its worst close to the edges of the field.

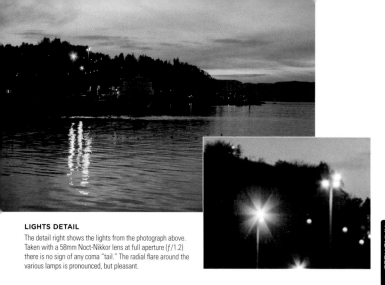

LIGHTS DETAIL
The detail right shows the lights from the photograph above.
Taken with a 58mm Noct-Nikkor lens at full aperture (f/1.2)
there is no sign of any coma "tail." The radial flare around the
various lamps is pronounced, but pleasant.

What counts as fast in a lens? Always, of course, the faster the better, but in the context of modern lenses, the maximum aperture should be greater than f/2. The fractional numbers at this end of the aperture scale belie the actual differences. A lens of f/1.4 captures twice as much light as f/2, and four times as much as a "regular" f/2.8 lens. The cost of doing this is considerable in terms of precision, type of glass, weight, bulk, and money. Hidden issues are the aberrations and edge performance failings that appear at very wide apertures. Nikon's 58mm Noct-Nikkor, for example, was designed especially to overcome sagittal coma, in which point sources of light appear crescent-shaped (or, as Nikon charmingly put it, like "a bird spreading its wings"). This aberration, disastrous for city lights and stars, disappears when the lens is stopped down just slightly, but to correct it for wide-open use the front element was ground aspherically, and highly refractive glass was used to allow all the elements to have shallower curvatures.

Wide maximum apertures at extreme focal lengths are even more difficult to manufacture, and practically this restricts the choice of fast lenses to focal lengths not far from standard. The range from 35mm to 85mm is the norm. With a fast lens being a considerable investment, deciding which to choose is important. The arguments for a wider angle are coverage and less risk of camera shake (as there is less movement of the image in the frame at a wider angle), but a possible disadvantage is that wide-angle views are generally, through familiarity, expected to be more or less sharp throughout the scene. The arguments for medium telephoto are that it makes a perfect low light portrait lens, and that the strongly blurred out-of-focus areas can enhance the sharpness of the focused zone; against this, coverage is restricted and camera shake more likely. We deal with focusing issues in more detail on the following pages.

Focus at Full Aperture

If you are used to the forgiving focusing range of a normal lens (and these days, full aperture on many zooms is $f/3.5$–$f/5.6$) then working to precision with a fast lens wide open can come as a shock.

For example, on my Nikon DSLR, using a Zeiss 85mm Planar at $f/1.4$ and focusing on a subject at 16.4 ft (5 m), the depth of field is around 7.4 in (19 cm). Compare this with the 30 in (77 cm) when the lens is stopped down to $f/5.6$. Depth of field is at best a fuzzy concept, and the calculations are not to be taken literally as it is ultimately based on the concept of "sharp enough," involving both judgment and the definition of the circle of confusion. The circle of confusion is the smallest diameter that an imaged point can be and still look like a point. If your eyesight is good, and you are examining the final photograph closely and critically, the outer limits of this depth of field may not satisfy you. This, as you might expect, tends to happen with photographers investing in and using one of these costly lenses.

In almost all short-to-medium-distance scenes, only a very small part of the image can be sharply focused at a wide aperture. This is even more pronounced if you use a medium telephoto portrait lens. Basically, depth of field is not an option, and there is usually no point in trying to maximize it. The only strategy worth pursuing to get more than one point in the image sharp is alignment—re-positioning yourself or some objects in the scene so that they are at the same distance.

Typically, however, the first consideration is identifying the exact part of the image on which to focus. Usually this is obvious, though

Compare focus

With the camera steadied to avoid the risk, focus at full aperture with a long focal length (here 85mm at $f/1.4$) on a subject containing sharp detail, in this case the metal grille of an audio speaker. Using manual focus, or manual focus override, take a series of frames with very slight differences in focus—though all should be visually sharp through the viewfinder. The focus indicator in the viewfinder will also help in this. Here, examining the frames together at 100 percent shows the slight focus shift, although at the time of shooting any of these would have seemed correct. For the purposes of this demonstration, I chose this speaker grille because of its slight curvature, and marked the sharp focus point with arrows.

not always, and there may be a conflict of choice, as in the example opposite. Having decided, be careful when relying on the autofocus to deliver the best result. As the image illustrates, in a deep area of the scene it is easy for the focus to be slightly, but significantly, out.

The problem is compounded greatly with manual focusing. As you may have noticed, some modern fast lenses are still made without autofocus—so why would a reportage photographer deliberately make life difficult by buying one of these? I can answer this question personally, as my last lens purchase was the Zeiss 85mm *f*/1.4 Planar just mentioned, even though I might have chosen the Nikon model for around the same price, with the same focal length, same maximum aperture, but with autofocus, which you might think essential in getting the focus exactly right. In many cases, it is faster and more accurate than manual focus, but it depends on the subject, and in low light photography, as we've seen, images can easily confuse automated systems of all kinds. Specular highlights and large, dense areas of shadow can easily throw autofocus out, with the added risk of your shooting without realizing this. Manual focus, while slower, gives more personal control, and the focusing indicators in the viewfinder frame are particularly helpful. But a more important reason is that fast lens design is at the specialized, craftsmanlike end of lens manufacture, and much attention is paid to the subtle qualities of out-of-focus appearance, contrast, and general, idiosyncratic feel, in addition to build quality. These lenses are not at the heart of mass-production, and so can be treated differently. The Zeiss lens, for example, is a Planar, which means it is optimized for a flat field across the frame.

ALIGNMENT TO SUBJECT

When composition and camera viewpoint permit, one standard method of maximizing the shallow depth of field at full aperture is to shoot perpendicular to the main axis of the subject. In the case of this mantis, the length of the insect obviously makes this worthwhile.

RANGE OF SHARPNESS

The gradual shift from sharply focused to unfocused across the plane of the image is often no bad thing, and the blurring can be attractive, particularly if it creates a kind of color wash. All that's needed is to focus on a logical point, of which there may be several. Here, with a glass restaurant wall, the first letter of the name is the logical choice.

One technique, which takes up more time, but helps guarantee the result, is to shoot extra frames with very slight shifts to the framing with the autofocus on. This slight re-framing will give you a range of sharp-focus points from which to choose later. Another precaution, which also delays shooting, is to set aside several seconds to examine the image at magnification on the LCD screen. Obviously, doing either of these depends on the kind of subject—one that is not changing or moving very much.

Where to focus

All kinds of detailed decisions are involved in where to focus whenever there is choice. In the case of this museum shot with a medium telephoto, slight adjustments to framing and the movement of the people in shot gave two possibilities. The basic framing is trying to juxtapose the paintings of standing women with real visitors, but full depth of field is impossible. In the first shot, the woman in the middle distance seems to be the natural focus of attention, but in the second, the action of the woman in the distance, holding up a camera and framed more neatly against the strip of white wall, shifts the attention to her, and so I shifted the focus to her also.

COMPARISON

This comparison makes it easy to see the two focus points—check the well-defined belt buckle and bag strap.

Defining Sharpness

Sharpness is almost always critical in low light photography, simply because the technical limits of depth of field and shutter speed are constantly being pushed.

First, however, it's important to understand that sharpness is subjective—an overall, personal assessment from a combination of factors which can include the resolution of the lens, the focus, noise, contrast, motion blur, and how closely someone examines the image. Most of the time in photography, sharpness is an ideal, or at least a desirable quality, but by no means always. There may well be other qualities that override the importance of sharpness. Consider a shot that captures a particular gesture elegantly but is ever so slightly less sharp in some respect than the following frame; yet the second frame is not quite so well timed. The content may well tip the balance towards the first. And in case we get too fixated on sharpness, let's recall Henri Cartier-Bresson's comment: "I am constantly amused by… an insatiable craving for sharpness of images. Is this the passion of an obsession?… Do these people hope… to get closer to grips with reality?"

A useful exercise is to make test shots whenever there is time, in advance of an important shot, and check them on the LCD screen at full magnification. Lettering of any kind, such as signs or vehicle number plates, is a good subject; the idea is to become familiar with what is an acceptable sharpness. It is very common, when editing a low light shoot, to find a proportion of images slightly unsharp for one reason or another (wrong focus point, subject movement, camera shake). Because these technical issues cannot be taken for granted in this kind of photography, editing takes longer. When examining the images in a browser or database, each one needs to be viewed at high magnification—full size or three-quarter size. Beware when deleting images not to throw away those that may have some use when repaired.

An important perceptual consideration is that wide-aperture shooting creates two different textures in the image, equally important. One is the small in-focus area, the

KEY SHARP DETAIL

For perceptual reasons, as long as one key detail in the image is sharp, the eye and brain accept and assume a greater sense of overall sharpness than may, in fact, exist. Here, a telephoto shot of men in a Burmese temple is sharply focused only on the eyebrow-to-chin profile of the further man and on the tobacco smoke he is exhaling. This is enough, however, to give a satisfactory general impression of sharpness.

Depth of field at wide apertures

Depth of field is the distance between the nearest and farthest points in a subject that appear acceptably sharp in an image. The smaller the lens aperture, the greater the depth of field. It is ultimately subjective, and influenced by the following:-

- Focal length
- Circle of confusion
- Aperture
- Subject distance
- Viewing distance of final image

When slightly out of focus, a point is imaged as a tiny circle. The circle of confusion (CoC) is the smallest that this circle can be and still appear sharp to the eye at a normal viewing distance. This is subjective, but most lens manufacturers work to between 0.025mm and 0.033mm for a 24×26mm frame (that of 35mm film). Smaller sensors call for a smaller CoC.

DEPTH OF FIELD

These berries are in sharp focus, but the high aperture means that closer foreground (the leaf) and background are not in focus.

other the surrounding, usually much larger areas that are out of focus. The quality and "feel" of these out-of-focus zones makes an important contribution, and is the reason why many photographers tend to be partisan about specific lenses. Lens designers do indeed work toward a particular style of "out of focusness," particularly with fast lenses. Not only are the out-of-focus zones important in their own right, but perceptually they contribute to the concentration of sharpness in the small focused details. Compositional techniques such as positioning a small sharp area against the extreme blur of a strongly defocused background aid the impression of sharpness.

Sharpness also needs to be considered in the context of digital sharpening, which we deal with shortly. At some point before final output, all digital images need sharpening,

because of the way they are captured, which introduces some softness, and because of the characteristics of the printer or other output device, so that the final image has the desired crispness and sparkle. These standard needs are not always easy to distinguish from the more localized and personal issues, such as repairing or enhancing details in an image which were not focused or frozen adequately— which happens frequently in low light photography. On the following pages we'll look at this as a separate sharpening procedure.

Stopping down from the maximum aperture is clearly one way of reducing the risk of imperfect focusing, but the cost is the noise from racking up the ISO—negating the very reason, of course, for using a fast lens. Nevertheless, this is one of the possible trade-offs discussed earlier, on pages 16–17.

The Technical Edit

In normal bright-light or flash photography, you might go straight to image selection on aesthetic grounds, on the reasonable assumption that the images will be technically competent.

Any serious issues, such as auto-focus incorrectly targeted on the background instead of the subject, would have flagged themselves at the time of shooting. Not so in low light photography, and particularly not so with handheld. As already discussed, the combination of shutter speed, aperture, and ISO setting is, for much of the shoot, likely to put you on the edge of acceptability.

Whichever browser, database or workflow program you use for selecting which images to process, the very first step is to check for sharpness, while also keeping an eye on the worst effects of noise. Sharpness, as we've seen, is more complex than it at first seems, and involves a heavy dose of personal judgment; grounds for rejection are generally poor focus, camera shake, and subject motion blur. At a finer level there are your own standards for what you consider truly sharp as opposed to "just" sharp—here the expressions "pin-sharp" and "tack-sharp" spring to mind. More complex is deciding between images in which the point of sharp focus varies, as this is more of an issue with wide apertures and longer focal lengths.

As one of the key strategies for handheld shooting at slow shutter speeds is to spread the risk by taking several-to-many frames, you will often have a sequence of very similarly composed images, and this helps the technical

DXO OPTICS PRO
A four-up display in the Organize section of the workflow can be zoomed in on equally.

LIGHTROOM
Here Lightroom is shown in comparison mode. When one picture is being viewed, simply click anywhere to zoom the view to 100%.

APERTURE
Aperture has a built-in loupe which can be called up and dismissed by simply pressing the "~" (tilde) key. The zoom ratio defaults to 100%, but can be adjusted.

check enormously—provided that the software you use for selection allows them to be ranged alongside each other on the screen for a detailed side-by-side comparison. The software packages here show the various alternatives, with some clearly better at comparative display.

Opinions vary on what to do once you've made a judgment. There are three technical categories possible: unacceptable, acceptable, and best. Some photographers prefer to bin the

clearly flawed images, but given that some repair may be possible, there are valid arguments for simply tagging them and keeping them. It's also worth bearing in mind that future software may be able to achieve more effective repair than at present. Added to this are creative or aesthetic judgments touched upon already, such as preferring the composition of one frame which may not be the absolute sharpest, but which is still acceptable technically.

Identifying Blur for Repair

There are two basic kinds of blur, which is to say two basic causes of unsharpness. One is focus blur, in which point sources in the subject reproduce not as points but as discs, and the other is motion blur, in which features in the subject that should be sharp in the image reproduce as streaks or smears. And there is every possibility that both kinds of blur appear combined.

Let's first consider focus blur, which through familiarity tends to be the standard against which other varieties can be compared. As we saw on the previous pages, focus blurring increases steadily according to the depth of the scene away from the point of focus. Most scenes shot at a wide aperture, therefore, contain many different degrees of out-of-focusness.

Perhaps the key quality of focus blur is that each point becomes a circle. We already saw this when we examined circles of confusion and depth of field. In digital terms, each pixel becomes a circle of pixels centered on the original point. This provides the basis for specialized image-restoration software to work. As the blur is isotropic (equal in all directions), knowing the blur width helps in attempting to reverse the blur toward the original sharpness. Technically, it is the Point Spread Function (PSF) that defines the amount of spreading—that is, blurring. As we'll see on the following pages, unsharp masking, which is the standard procedure for most image sharpening, including in Photoshop, is not necessarily the ideal for repairing this kind of optical blur. A point to note here is that with a perfect lens (an impossibility), the PSF predicts a perfect circle, but in real life the blur shape is often different, if only slightly so. Sophisticated blur repair needs to take this into account, and

as the examples on these pages show, blur shapes can differ. Unsharp masking, incidentally, assumes that the blur radially follows a Gaussian (bell-shaped) curve (see box on page 86).

The ideal feature in an image to use for identifying focus blur is a point that contrasts strongly with its setting, and the perfect example of this is a specular highlight. While it is impossible to predict or determine which bright points of light are indeed points and not circles to begin with, reflections of a light in a curved surface (sun on raindrops, distant electric lamp in spectacles) and refractions (light sparkling in jewelry) tend to be small enough in a typical image to have no measurable dimension. When sharply focused, these appear as points, but the more defocused they are, the larger the diameter of disc they become, as in the sequence here. More often, however, there are no such easy point-source clues, and you may have to fall back on other ways of examining the image. One clue is to find parts of the image that commonsense tells you are closer or further than other parts, and to look at magnified details to see if they differ in sharpness.

Alternatively, there is the heuristic approach, a fancy way of saying try out focus-repair procedures to see if they have any effect. In the case of the program used on the following pages for repair, Topaz InFocus, this involves letting the software analyze details, and also alternating between focus-blur repair and motion-blur repair. This is a rough and ready method, but can work.

Unsharpness due to movement has special qualities that sets it apart from defocused blur, and it can be further subdivided into camera motion blur and subject motion blur.

Blur shapes

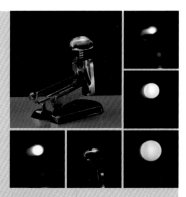

DEFOCUSED SPECULAR

The specular highlights of the sun in the rounded chrome-metal top of a simple stapler are ideal for a focus-blur test. The image is defocused in stages, and the blur shape from a high-quality lens (a Zeiss Planar) stays circular. Note, however, that one of the characteristics of this very sharp lens is to create an annulus (outer ring) to the blur circle, in a color that derives from axial chromatic aberration.

DISTORTION INCREASING WITH BLUR

Details from three separate exposures at different focus points made of the Pudong skyline from Shanghai, on a 28mm PC shift lens. The distortion, stretched toward the center of the lens's field of coverage, increases with the amount of defocusing.

COMA

Sagittal coma shows itself as a curved, stretched shape that points toward the center of the image, and is worst at wide apertures with wide-angle lenses near the edges of the frame, as shown here.

Motion blur differs from focus blur in that it has direction, and if you know or can calculate this direction, it is easier to restore than focus blur.

The effect is a kind of smearing, though it's important to distinguish between camera shake and subject motion blur. In the first, the entire image is smeared by the same amount because the camera rather than part of the subject has been moved during the exposure. Subject motion blur involves relative motion—one thing moving against a background, such as a car. This kind of relative motion is more difficult to restore than camera shake, because it needs different amounts of correction across the frame.

There are further subdivisions, and ultimately a wide variety of motion-blur images. Camera shake involves both time and direction; the longer the exposure, the longer the streaks will be. Deliberate motion blur by moving the camera often involves changes of direction. A special case, more relevant to tripod shooting, is a medium-long exposure in which the camera shake, from mirror slap or a heavy finger on the shutter release, returns to the original position, creating a very lightly separated double image. In subject motion blur, a major distinction is between the way a light subject moves against a dark background, and vice versa. Time and direction also matter.

Default blur is Gaussian

Most focus blur is not only radial but its effect on the image follows a Gaussian distribution. This means, in effect, that the blurred image of a point source of light fades away from the center like the 2-D projection of a 3-D Gaussian bell-shaped curve, as shown here. You can see this in action in Photoshop by creating a white dot on a black background and then applying *Gaussian blur: Filter > Blur > Gaussian Blur* (to see the effect clearly, give the dot a radius of at least a few pixels).

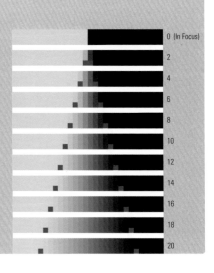

	0 (In Focus)
	2
	4
	6
	8
	10
	12
	14
	16
	18
	20

Defocusing a point source

A specular reflection in a convex surface, such as this lacquer bowl and silver containers, is probably the ideal feature in a photograph for displaying the effect of focus blur. In these example sequences of details from the same image, the first row shows progressive blurring from sharp as the lens at full aperture $f/1.4$ is progressively focused forward (closer to the camera). The second row shows the same focus settings at the smaller aperture of $f/6.3$, and the third row is at the much smaller aperture of $f/16$. Note that the classic radial blurring of point sources is really only obvious at a wide aperture; the blurred points at smaller apertures retain more of their original shape.

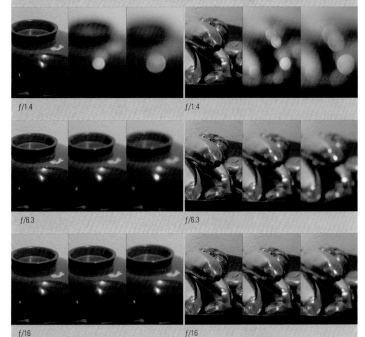

$f/1.4$ $f/1.4$

$f/6.3$ $f/6.3$

$f/16$ $f/16$

Gallery of blur types

UNI-DIRECTIONAL CAMERA SHAKE

Specular highlights in the metal surface are good indicators of the direction, uniformity, and length of motion blur. As it affects the entire image, this is clearly camera shake. Extremely straight blur movements like this are also typical of motion blur caused by slippage or knocks to a camera mounted on a tripod.

BASIC FOCUS BLUR

The problem here, as revealed by a magnified view, is an overall softening of focus, typical of focus blur.

Before correction

After correction

Topaz infocus

SLIGHT MULTI-DIRECTIONAL CAMERA SHAKE

A magnified view of the selected area shows a consistent pattern that reveals a 13-pixel shift—just within the limits to expect repair—but with a curve at one end like a hook, which will limit the effectiveness of repair tools.

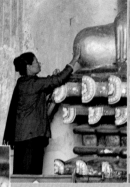

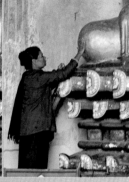

Original After Noise Ninja repair

PRONOUNCED MULTI-DIRECTIONAL CAMERA SHAKE

The camera shake here is deliberate and long—and moved around the subject—but it also combines with subject motion blur. Analyzing two areas of the image shows the curved movement of the bulls' horns—specific and different from other movements such as the matador's—but the area of the ground upper left shows the actual camera movement, a curve toward the lower right, with a jerk at the end.

Gallery of blur types

PRONOUNCED UNI-DIRECTIONAL CAMERA SHAKE

A magnified view of the man's head (and we can see that he appears to be standing still) shows at least two clear points of movement, in the same direction, of some 40 pixels, which is too great to attempt any repair.

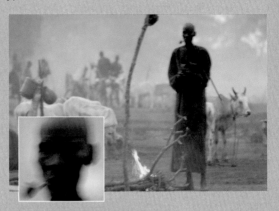

PROGRESSIVE FOCUS BLUR

In most images of scenes with some depth to them, you can expect a progressive increase in focus blur. In this scene inside a Burmese temple, magnified views of three sections show a visual defocusing in the direction of the arrow. Using Focus Magic to make an analysis of the amount of blur by clicking the Detect button confirms the progression.

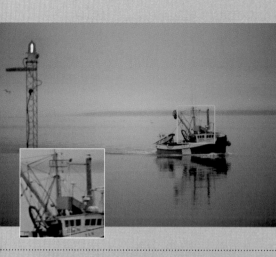

SIMPLE, SHORT SUBJECT MOTION BLUR

A fishing trawler entering a harbor has a predictable and known movement in one direction, and at a slow shutter speed because of the light (pre-dawn), you would expect some short motion blur. The obvious places in the image to look are narrow edges perpendicular to the expected movement (the vertical rigging) and indeed they do reveal blurring, in contrast to the horizontal rigging, which doesn't.

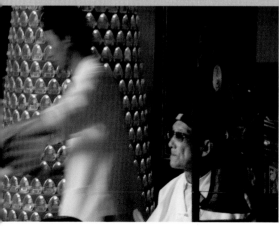

COMPLEX SUBJECT MOTION BLUR

The standing figure moves predictably from right to left, by approximately 5% of the image frame, equivalent to about 200 pixels. However, different parts, such as the arms, can be expected to move in different directions and by different amounts.

Repairing Focus Blur

In principle, sharpening can be put into three categories (though the practice may be different). The first is sharpening to overcome softness introduced during capture, of which there are two components: optical softness from the lens, and digital softness from the sensor.

Most lenses show soft spots in different parts of the images area and at different apertures. The sensor and the processing of the signal it captures also introduces softness when continuous tones are translated into pixels on a regular sampling grid, and details that are finer than the sampling frequency are averaged by interpolation. The second category is sharpening for creative or repair reasons, applied to details identified by the photographer. The third is sharpening targeted to the needs of the output device, such as a printer. Although capture-repair-output is a logical time sequence for performing sharpening, standard professional practice in photography tends to demand that images stay unsharpened until final use. Stock agencies in particular, and a few clients, are familiar with sharpening artifacts, and may well reject images that have been sharpened in such an obvious way.

ORIGINAL

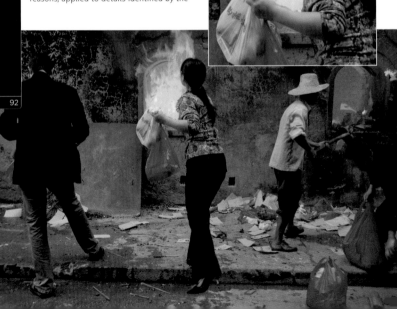

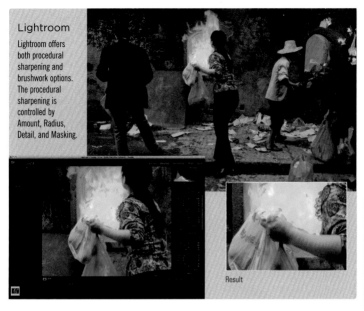

Lightroom

Lightroom offers both procedural sharpening and brushwork options. The procedural sharpening is controlled by Amount, Radius, Detail, and Masking.

Result

This, however, is a contentious area, because the real reason for not wanting sharpening performed early in the workflow is the danger of artifacting. The key artifacts in question, which are always sufficient for a stock agency, for example, to reject the image, are scattered dark pixels and halos, both bordering edges. Acceptable, and usually not even visible, on a printed page, these are usually obvious and objectionable in an image viewed onscreen. The reason they appear at all is that throughout photography and printing, the usual way of sharpening an image is to increase the contrast at edges within the image. This has everything to do with the psychology of perception, because we judge sharpness most in local detail, and particularly in terms of contrast.

In practice, the first two purposes are usually combined, and can usefully be kept separate from the third. Procedural sharpening passes are always best left until the last minute, and on a copy, because the amount of sharpening is partly determined by final use— the size of reproduction and the characteristics of the output device. This leaves creative/repair sharpening, which is much less amenable to procedural techniques, as we'll now see. It also needs to be done circumspectly, paying special attention to avoiding tell-tale artifacts as evidence, for the commercial reasons just mentioned.

First, procedural repair. This means an imaging operation, such as a filter, applied algorithmically, usually across the entire image. The opposite is direct brushwork. There are two schools of thought here. The argument in favor of procedural sharpening is that if the cause of the blurring had an overall effect and

DXO's Lens Softness deconvolution

DXO OPTICS PRO

As one part of its overall image processing, DxO uses a painstaking analysis of specific lens-sensor combinations to calculate their exact blurring effect in each part of the frame and at every aperture setting. The algorithm reverses this blurring, with the default auto setting being the software engineer's judgment. A slider allows the user to lessen or increase the strength. Because this deblurring is applied to known defects in the lens and sensor, it differs from ordinary USM sharpening in that it is applied selectively.

The default settings in Lens Softness using DxO Optics Pro. This applies pre-calculated corrections to a lens and camera combination that has already been analyzed and is in the software database.

can be analyzed, it can be reversed with an algorithm. The major argument against is that sharpness is perceptual and so largely a matter of individual judgment, so sharpening the entire image is overkill. The argument in favor of brushwork applied to chosen details is that this can address just the areas that you decide are important, and do so without pixilated artifacts. Against this is the ethical point that brushwork verges on alteration and manipulation.

A better procedural choice is dedicated deblurring software, of which there is surprisingly little available commercially. I say

surprising because deblurring and image restoration receives a great deal of scientific attention, and is used in military applications. One program available on both Windows and Mac platforms is shown here, Topaz InFocus. It works on both focus blur and motion blur. In the former, the blur is radial outward, and the software attempts to reverse this process by moving pixel edges back toward the center of what it computes to be the original source. In the case of motion blur, the process is in principle the same, but the pixels are shifted in one direction only. As explained in the box

Topaz InFocus

This software works by first estimating the blur radius in pixels, and then applying a special algorithm designed to reverse the process that created the blur. Set Blur Type to Unknown/Estimate and click on a part of the image with clearly defined edges. Some trial and error experiments at different radius settings are useful in judging the most effective one.

"Convolution and deconvolution," deblurring is based on analysis of the original capture. InFocus does this by having the user examine the blur shape and put numbers to it. DxO Optics Pro, as part of its Raw conversion package, refers to lens modules that the company has already prepared by analyzing the performance of individual lenses used with particular sensors.

There are limits to what deblurring software can do, and it works best when there are plenty of linear boundaries to work on. The practical limits are effectively less than 20 pixels, meaning less than 20 pixels blur-width in the case of focus blur, and smear-length in the case of motion blur.

Returning to Photoshop and other image-editing programs, most have similar filters, and there are procedural alternatives to USM (Unsharp Mask). Smart Sharpen allows you to select sharpening aimed at optical blur via the Remove drop-down menu. Lens Blur deals with focus blur, and Motion Blur does as it says, requiring the user to set the angle. Another effective treatment, with little noise effect and reasonable control over halos, is High Pass sharpening. This is a two-step layered procedure, in which a duplicate layer is made of the image. A high pass filter *(Filter > Other > High Pass)* is then applied to the duplicate layer, then this is changed to Hard Light mode. Overlay mode is slightly less

Convolution and deconvolution

Processing optical blur and lens softness is not a simple procedure, as it means first identifying the amount and type of blur and then attempting to reverse the process mathematically. Lens blur is described mathematically by convolution, repairing it is deconvolution. Convolution is a mathematical operator that combines two functions to make a third, and one example in optics is a shadow, which is the convolution of two things—the shape of the light source and the object that casts the shadow. Optical blur is the convolution of the sharp image with the shape of the aperture diaphragm in the lens. In other words, apply the aperture shape at a particular f-stop in a certain way to a point in the image, and the result will be a specific shape and size of blur. Motion blur is also a convolution, of the sharp image and a linear movement.

In the example here, convolution can be thought of as a moving average applied to each pixel over a certain radius. At its simplest, a black pixel on a white background is averaged to a pale gray. A solid color, say all black or all white, is unchanged. Applying this across the entire image, pixel by pixel, has the effect of blurring sharp points and edges but leaving solid areas untouched. This is the blurring process.

The aim of deconvolution is to reverse what happened, and so de-blur the image. It depends very much on being able to describe the original blurring precisely. The PSF (point spread function) describes this mathematically, but is difficult to calculate unless the software designer knows the exact performance of the lens in combination with the sensor. The shape of the blur from a single point can vary considerably from the simplest case of a round disc, depending on the characteristics of the lens and sensor, its position in the image frame, the f-stop, and so on.

Deconvolution (or deblurring) effectively sharpens the image, and the difference between this and normal sharpening is largely a matter of terminology. In a sense, deconvolution/deblurring is a form of sharpening with a specific goal, while normal sharpening is open-ended.

In focus blurring, a black pixel on a white background would be convolved to gray...

...but black blurs to black...

...and white blurs to white.

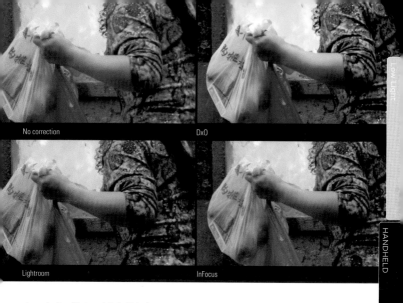

No correction

DxO

Lightroom

InFocus

strong in its effect, and Soft Light less strong again. The High Pass filter retains edge details where maximum color transitions occur. However, it must be said that at this time the Photoshop deblurring filters are not at all sophisticated in their operation, and fall short of the dedicated third-party software just described.

Non-procedural restoration works in an entirely different way, and is more intuitive and hands-on. There are few "silver bullet" solutions here that will magically and quickly improve the image; instead there is painstaking brushwork at 100 percent and 200 percent, calling on the skills of the miniaturist rather than the computer engineer. The key steps can be summarized as follows: identify where in the image the eye will travel to most insistently to search for detail, then work on these at a high magnification to enhance local contrast and edges, working with a variety of brushes.

A FOUR-WAY COMPARISON

Clockwise from top left: No correction, DxO, Lightroom, and InFocus. The most successful in this example is InFocus, with no unnecessary edge-sharpening with consequent halos (as happens marginally with Lightroom). DxO also handles the lettering well, but is less successful than either Lightroom or InFocus with the lace outlined against the flames.

Which brushes is a matter of personal preference, as is the choice of brush hardness, but the Clone Stamp and Smudge tools are both useful, not least because they make use of existing pixels and pixel distribution.

The examples here tell the story best, as this kind of retouching does not lend itself to generalization. Brushwork can, of course, be combined with procedural sharpening, either to make very detailed selections before applying a filter, or to take over in key details when the filter has done as much as is realistically possible.

Repair to Extend Focus

Although an image that is completely out of focus and nowhere near sharp is usually considered a reject (though not always), gradations of sharpness are an absolutely normal part of photography.

Because of the way the eye and brain work, we are only rarely ever conscious of this kind of optical blur in real life, as our gaze flicks rapidly from one part of a scene to another, refocusing almost instantaneously. Nevertheless, more than a century of looking at photographs has made depth of field (see definition) a normal feature of imagery. Particularly in a long-focus picture, it is completely acceptable to have blur at the front and back around a limited sharp zone, and even attractive.

Because low light shooting handheld inevitably means a wide aperture, almost all images shot with a long focal length will have very shallow depth of field. Obviously, one of

the shooting strategies is to use this creatively, making compositions that work around a single sharp point, perhaps using the blurred zones to point this out or else as a color wash. At other times, we would really have preferred to have greater depth of field but have to settle for shallow.

For some distance beyond the depth of field, the soft focus can, in principle, be treated in the same way as we've just seen with overall soft-focus blur. If it's possible to isolate these zones somehow, they can be processed with a focus filter. Dividing an image according to depth is at best a fairly arbitrary procedure. By doing it after the event, there is no direct measurement possible to construct a depth map. The only evidence is a commonsense reconstruction from what you can see in the image, but in a case like the example here, there are no ambiguities. We know what a

FOCUS BLUR ANALYSIS
Comparing different parts of the truck shows the progression of focus blurring towards the back.

MOVING VEHICLE
The original image of a truck on a Canadian highway was shot from an overpass with an extremely long and fast telephoto lens. With a focal length of 600mm, and at $f/4$, the depth of field was extremely shallow. This is the result after extending the focus.

FOCUS PLAN
For the purposes of this demonstration, the image is divided into focus zones, each needing different amounts of correction.

Depth of field

This is the extent in front of and behind a sharply focused distance that still appears to the eye to be acceptably sharp. It depends on aperture, focal length, and the distance between camera and subject, but above all is a subjective impression. The smaller the aperture, the shorter the focal length; and the further the scene from the camera, the greater the depth of field. Nevertheless, what one person deems acceptably sharp may not be the same as judged by someone else.

truck looks like, and which parts will be in front of which others. Remember also that here we're after visual effect, not precise measurement. The color-coded focus plan is included to show approximately the plan for extending the depth of field. It is not for any procedural use, just a quick analysis of the different planes of softness.

The principle is to first decide how much of the soft zones beyond the depth of field can realistically be brought back toward sharpness. Bearing in mind the 20-pixel maximum practical radius (see page 95) and the fact that large-radius filtering runs the risk of looking unnatural, it may be worth selecting two or

three zones of increasing blur, then running the filter at different settings for each.

There are several options for doing this, but all depend on some form of manual brushing. One is to paint a mask on the image to cover a zone (Quick Mask in Photoshop), then apply the filter to that, repeating the process for other zones. Another, which allows a better overall view, is to apply the filter at a particular setting to an underlying duplicate layer, and then selectively erase the top layer. A third method is to apply the filter, then use the History Brush to restore the already-sharply focused areas to their original state.

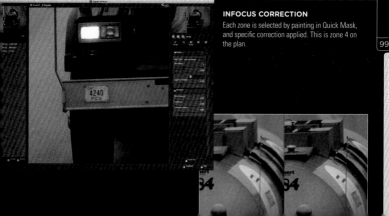

INFOCUS CORRECTION
Each zone is selected by painting in Quick Mask, and specific correction applied. This is zone 4 on the plan.

Repairing Motion Blur

Going back to the types of blur identified on pages 84–91, the key difference between focus blur and motion blur from the point of view of repairing them is not how they were caused, but rather the shape of the blur.

The Point Spread Function for focus blur gives a radial pattern—from point to disc, in other words—but motion blur is unidirectional and at a particular angle. You could say that both focus and motion blur are versions of the same effect, and for repairing them the software problems are similar.

The procedure, too, is similar. First the motion blur has to be calculated; in terms of how many pixels in length and in what direction, measured as an angle. Then the software has to attempt to move edge-defining pixels back to where they should have been, by exactly that many pixels and in that direction. This is no easy calculation, because it is applied to the entire image and within this the algorithm must distinguish between edges and more amorphous zones. Photoshop has such a filter, which can be found by choosing *Filter > Sharpen > Smart Sharpen* and, under the Remove heading,

selecting Motion Blur. However, as the example here shows, this is really just a variant on unsharp masking, and while it may improve the appearance to an extent (depending on the specific image), it is not actually reversing the motion blur.

The more effective software is InFocus which, up to a blur distance of several pixels, can impressively reveal detail that was not visible in the original image. An acid test of the efficiency of motion-blur repair is what the software does to a distinct, simple line that is more or less perpendicular to the blur angle. Typically, it appears in the original as a thicker band instead of a line. Effective repair will restore it to a line.

NUN

Small details that contain lines or edges running in different directions are ideal for assessing direction and amount. Here, the fold in the cloth is sharper than the edge. Matching the direction of the fold by eye with the Blur Direction setting confirms the direction at 100°.

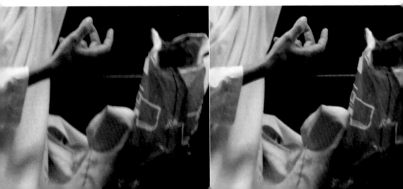

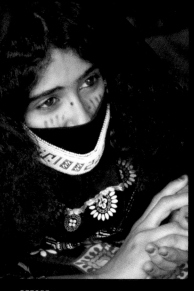

Too much

Too little

Just right

AFTER

BEFORE

Having established the blur direction, using the plentiful detail in the bead jewelry, experiment with different Blur Distances. Here 1 pixel is too little, and 4.5 pixels too much. The ideal setting is 3.7 pixels. See the effect on the eyes and on the white beads.

DETAIL VIEW

As ever, the best way to see your work is to view it at 100% or a multiple thereof (200%, 300%, 400%, and so on). These scales do not require interpolation to be displayed, so are the most accurate.

BEFORE

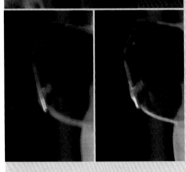

INFOCUS

For this image, setting Motion Angle to around 60% with a Blur Radius of just over 2 produced the best results.

AFTER

Predictable shapes

The key to this kind of correction is finding the most appropriate detail in the image. Circles and other predictable curves are good because they identify a progression. This ring also contains specular highlights, making it even easier to measure the blur. For confirmation, look at a similar frame that is sharply focused.

BEFORE

INFOCUS
Using InFocus' Unknown/Estimate setting produced

AFTER a distinctly sharper image.

Gross Motion Blur

In the example here, the motion blur is so strong that it is an inextricable part of the image. In fact, it is due to a slow shutter speed and a panning action.

The immediate issue is whether or not the photograph makes it at all. Does it succeed, or rather could it succeed with post-production help? At this degree of motion blur, there are no generalizations. Everything is in the specific. Opinion also tends to be specific, and personal. Let's say that in this case (a mistake, actually, as I had the shutter speed set slower than I had thought) I had intended the picture to be sharp and was disappointed that I had got it wrong, but that later I grew to like it. The problem, again always specific, was that there was no anchor-point of real sharpness anywhere in the frame. In particular, the eyes at least needed to be sharp to some degree. In general, the eyes are the focus of any face, and it's almost impossible to escape the need for them to have sharp edges.

Using the techniques already described, the motion blur here can be analyzed to a distance of many more pixels than the capability of focus-repair software. Also, at this amount of movement, the smearing is wobbly, which lends itself even less well to procedural treatment. The only reasonable procedure is manual, in other words brushing by hand.

The interesting point here is that very few parts of the image need to be sharp in order to make it visually acceptable. What rules is a knowledge of human perception. The content, even though unfamiliar to most Westerners, is nevertheless quite understandable. A Vietnamese man wearing a military pith helmet of the Vietnam War vintage, is smoking a large bamboo pipe. This reads at a glance. All that is needed technically is to introduce some key sharpness at a few well-chosen points, after which the remaining blur will be completely acceptable. The details that need sharpening are precisely located but obvious, and can be summarized as follows: the eyes as always, a re-definition of the mouth, and nearby distinct edges. No more than that.

BEFORE

AFTER

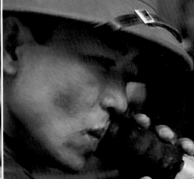

Using the buckle

SPOTTING THE BLUR

The metalwork on the pith helmet is an ideal indicator of the direction of the motion blur, which can be fixed in InFocus. But applying it to the face creates unacceptable artifacting.

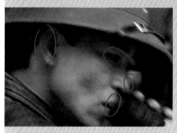

AREAS FOR MANUAL CORRECTION

Instead, the key zones for manual retouching are identified as the eyes, ear, and nose.

EYE PLAN

The plan of attack for the eye is to use the Smudge tool in specific directions, followed by a darkening with the Burn tool.

Clone stamp (hard edge)

Clone stamp (soft edge)

NOSE AND MOUTH PLAN

The Clone tool settings chosen for sharpening the edges of the nose and mouth, working from the outside for the nose and from the inside for the lip.

EAR PLAN

The Clone tool settings chosen for sharpening the edges of the ear.

Frame Selection and Layer Blending

Shooting extra frames to guarantee sharpness is good practice when the lighting conditions are pushing the limits on camera shake, motion blur and accurate focusing (see pages 64–69).

What then usually happens is that the sequence is examined carefully and at magnification to find the best shot—technically and creatively. The choice may be obvious, but sometimes you may find that two or three frames each have some advantage. The focus may be sharper in one but the composition better in another, or there may be unwanted subject motion blur in the sharpest version. In this case, there is another solution, though it may not appeal to everyone. This involves taking the best of one and adding to another.

The principle is straightforward—layering the images in register, then erasing the unwanted parts of one. As long as the frames are matched for their content, color, brightness and contrast, this gives you the freedom to have the best of both.

Under the circumstances illustrated here, where we are essentially dealing with a rapid burst of shooting, matching color, brightness, and contrast is not normally an issue. Typically, load the frames together into the Raw converter (you'll notice that I'm assuming throughout this book that everything is shot in Raw), Select All, and adjust as necessary. Even if there were exposure differences between frames, simply toggle back and forth from one frame to another and adjust until they are visually matched. More demanding is getting the frames in register. The manual method is tedious: copy one frame onto another as a separate layer, set the Opacity of the upper layer to somewhere around 60 percent so that you can see both images but one is more prominent, zoom in to 50 percent or 100 percent, and use the arrow keys to align them as well as possible. When they seem to be in register, set the Opacity of the upper layer back to 100 percent and check the register by toggling the visibility of the upper layer off and on repeatedly. Registration becomes more difficult if there has been rotation between the images, because to adjust this (in *Edit > Transform > Rotate*) you need to see the entire image, making exact alignment harder to judge.

This operation has been made much more feasible with Photoshop's Auto-Align Layers function. First lock the layer you want to use as a reference (if it is the Background image it will automatically be locked), then select both or all of the layers that you want to align, including the reference layer, then go to *Edit > Auto-Align Layers*. The Reposition Only option should normally be sufficient if there was little camera movement between frames, but the Auto option will automatically make whatever geometric transformations are needed. Note that because this automatic alignment is based on the software's analysis of content, it may make compromises that you don't like. For example, if there has been a parallax shift of foreground details due to slight movement in the camera position, the alignment process, which is of course based on image content, may base its calculation on foreground or background.

Finish the alignment if necessary by using any of the tools in *Edit > Free Transform*, and/or making tonal adjustments to even out any exposure or color differences. Once the images are aligned and matched for tone and color, use the Eraser for a direct replacement of less-sharp areas. An alternative to the Eraser is to mask the layers which is completely non-destructive, but the undo tool is always available in ordinary editing and is quicker and easier to access, and creates smaller files.

Night-time traffic and people

While these adjustments are not absolutely critical in this case, this sequence of three shots (taken within the period of a single minute) allows a final composite that both eliminates the streaking of moving vehicles, and shows a denser mass of pedestrians. The workflow goes as follows: first compare the images and work out a plan of what to keep and what to eliminate, then cut-and-paste them into a layer stack, align them and finally erase the unwanted elements.

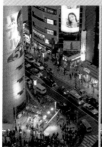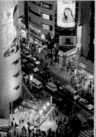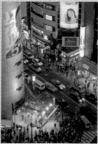

CHOOSING THE IMAGES

Examining the three images side by side, I could quickly devise a plan. In the center is the reference image, in which most of the traffic is stationary, bar three moving vehicles. The left-hand frame has much the same traffic and can be used to replace the vehicle streaks, while the right-hand frame has generally more crowded sidewalks, and the building on the right has a more easily readable blue-tinted video screen.

AUTO-ALIGN

Begin the Auto-align process by clicking *File > Automate > Photomerge* and selecting Auto.

PHOTOSHOP LAYERS

The three images are added to the same image as layers.

RAW PROCESSING

All the images are processed at once in ACR.

ERASING

Using the Erase tool or, if you are familiar with them, the Masking options, parts of the upper layer are removed to reveal the similar image from below. Here, for example, the blurred van is removed.

Combining best gesture and shake-free background

From a sequence of nearly identical frames, all shot at 1/15 second with an optically stabilized lens, there were a few shake-free and also a choice of the position and actions of the priest, who was cleaning the altar of this large and busy temple in southern China. Combining the sharpest frame, free of camera shake, with the preferred gesture of the man, allowed the best of both worlds.

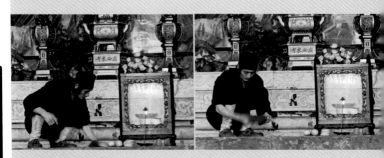

FIRST CHOICE OF SUBJECT
The preferred priest image.

FIRST CHOICE BACKGROUND
The preferred background.

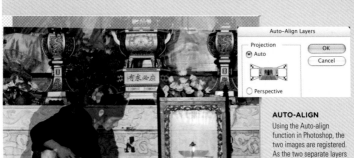

AUTO-ALIGN
Using the Auto-align function in Photoshop, the two images are registered. As the two separate layers show, there is an offset.

TEMPORARY OPACITY

In order to erase only those areas with underlying matched background, the upper layer is set to 50%.

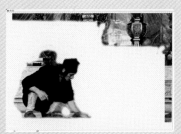

ERASING UPPER LAYER

The upper layer is erased selectively, here made obvious by making the lower layer invisible for purposes of demonstration. Note that because the two pictures were not framed identically, the very top is left untouched, although it has some camera shake; this is judged to be unimportant because it is away from the picture's center of interest.

FINAL RESULT

The layers are finally collapsed and the image cropped for the final combined result.

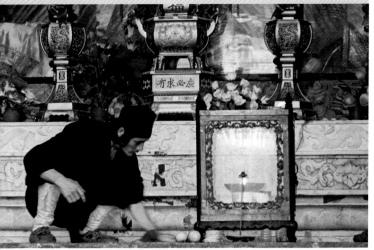

Tracking for Sharpness

As anyone who has had the experience of aiming at a target knows, whether with a rifle or in archery, holding steady on a fixed target is by no means easy, both mechanically and psychologically.

Indeed, the longer you try and hold, the more likely involuntary movements are (discussed on pages 68–69). Introduce movement, however, and things become more fluid and steady, due to inertia. The same applies to handheld photography and the time-honored technique of panning: swinging the camera from one side to another to follow a moving subject can produce surprisingly sharp results at slow shutter speeds. The principle is that you make use of inertia (mass × velocity) to overwhelm smaller jiggles. When combined with vibration-reduction technology in the lens (see pages 72–73), this can be a surprisingly effective technique in keeping at least some part of the image sharp.

Panning is the action of moving the camera to hold steady on a moving subject, but the reverse situation is also possible—moving the camera from a moving vehicle to hold onto a stationary subject. The detail effects are different, but the principle is the same. There is always an amount of uncertainty in doing this, but it is quite often worth trying, just to see what turns out. The instant feedback from digital lets you judge immediately whether to save or delete, and whether to continue with different settings.

There are some perceptual factors at work, too. Just as the range between sharp and blurred focus is greater with a fast lens used to isolate a detail at full aperture to help the focused subject to stand out, so the motion smearing from a panning shot helps to accentuate the part of the subject held in crisp detail.

Increasing the time that the shutter is open, and particularly over half a second, makes the outcome quite uncertain, not only due to prolonged subject movement, but because camera shake makes a bigger contribution. The effect then merges with the subject of the following pages, intentional motion blur.

HIGHLAND STAG
Using a 400mm lens from a standing position, a Scottish Highland stag captured at 1/60 sec and ISO 400.

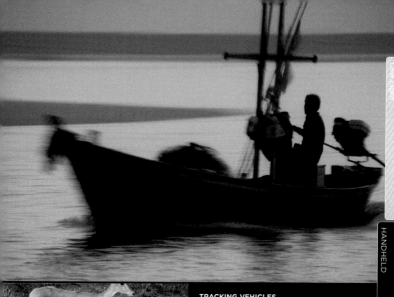

TRACKING VEHICLES

A different kind of tracking, also from a moving vehicle, in this case a boat in the Gulf of Thailand at dusk. The shutter speed of 1/3 sec with a focal length of 200mm is far too long for a truly sharp handheld shot, even with vibration reduction activated, but the combined motion of the two boats, plus the steadying effect of a slow pan, give an interesting result that achieves just-acceptable sharpness in the man at the tiller.

MIGRATING BEAST

White-eared Kob beginning their annual migration across the Nile valley in southern Sudan, photographed with a 180mm lens from a height of about 100 feet, through the open door of a light aircraft. With the aircraft traveling at around 100 mph, the antelope running at around 30 mph, and a reverse pan with the camera (against the direction of movement), this is a complicated tracking shot that manages to hold most of the animals sharp at a shutter speed of 1/35 sec, wide open at f/2.8.

Making Motion Blur Work

Motion blur is not all bad. Despite all the efforts that we normally make to avoid it and correct it, which we've just examined in more than usual depth, there are occasions when it can actually make the image.

Most photography has some documentary quality to it in the sense that it is showing a lucid view of something—a place, an event, a person—but photographs also have graphic qualities just as do paintings. The streaking and smearing effect of significant blur reduces the information content, but it can make the image more interesting, even intriguing. Sometimes photographs work better if they don't reveal their content all at once.

In particular, motion blur does best what its name suggests. It gets across the sense of movement, and it does so in a graphically dynamic way. Moving objects photographed with a shutter speed sufficiently short to freeze them against their background have a curiously static quality at odds with the event. There may not be any clues in the picture to show that a car, for instance, was actually in motion. It could have been parked, and even if we know that it was moving in real life (a car in the fast lane of a highway is unlikely to be stationary), the quality of speed is often missing in the photograph. This does not necessarily matter at all, as we're accustomed to the way photographs look, but it does open the opportunity for using a slow shutter speed to enhance the sensation of speed.

The key to all of this is occasional use. Using motion blur frequently as a graphic device simply becomes a mannerism—it is more effective when it appears as a surprise. Shooting handheld means introducing movement in to the image by the way you move the camera. This adds to any movement in the subject for an effect that can be complex and difficult to predict, which is one of its attractions. There are a number of examples from the history of photography, and one of the most notable were the several "motion" series shot by Ernst Haas in the 1950s, on subjects as diverse as bullfighting, rodeos, and motor racing. The swirling and streaked smears of color give an impressionistic effect. The results are always specific to the situation, so this technique calls for experimentation. Two key variables are the shutter speed and the kind of movement you introduce by shifting, shaking, jerking, or rotating the camera.

REVEALING MOTION

A Sufi adherent in Omdurman, Sudan, performs an ecstatic whirling dance. Fading daylight gave the choice of a sharp image at a high ISO, or the much more evocative and dynamic result chosen here by using a shutter speed of 1/30 sec.

VERY LONG SHUTTER

Panning with a long lens (400mm EFL) and a very slow speed, the aim of this shot was to convey, just, the top-hatted attire of brokers in a City of London street —a deliberately impressionistic treatment that was felt to be stronger than a literal and sharp image.

GETTING NOWHERE FAST

A planned shot of a hotel gym, where a slow speed of 1/4 sec at ƒ/9 was needed in order to give some sense of action to what otherwise could have been a lifeless image.

ON SCENE

As part of a feature on traffic accidents in Bangkok, this overturned pickup, its driver already taken to hospital, was photographed with a deliberate jerkiness and at 1/3 sec (at ISO 800) for a sense of movement.

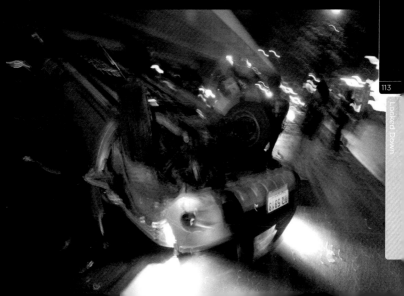

Raw for Low Light

Using the Raw format for shooting is now the professional standard in almost all kinds of photography (news, sports, and when fast delivery overrides post-production are the notable exceptions to this rule).

Its two most outstanding benefits are first that it preserves the capture data separate from whatever settings were applied at the time of shooting, so allowing color temperature, for example, to be chosen later. Second, it can record a wider dynamic range than other formats.

Given the typically major shifts of color from one scene to another in low light photography, and the fact that they are often unpredictable, the settings-change features alone make the Raw format almost essential. Most digital photographers are by now familiar with the concept of Raw, but to summarize briefly, these are proprietary image formats devised by the camera manufacturers, each one different, with the intention of receiving post-camera processing in specialist software tools. Saving images in Raw rather than going straight to JPEG in-camera gives you access to the original capture data. All Raw converter software programs—and there are now many on the market—provide image-editing tools to extract the maximum usable information from the data, and convert it to a useful format such as TIFF, JPEG, or DNG (the open-source Digital Negative format promoted by Adobe for archiving Raw files). Between the converters there are variations in the number of features, how the controls work, and the way they read and interpret the data (much of which is undocumented, being part of the camera manufacturers' code). Nevertheless, all do a good job.

High contrast is also a feature of many low light scenes that contain artificial lighting.

This is partly because of the pooling of light from localized sources, and partly because the light sources themselves, such as desk lamps or street lights, appear in shot. High contrast scenes have a higher dynamic range than normal, and importantly, higher than can be rendered by a standard 8-bit image. Bit-depth is directly related to the dynamic range that a format can cover and, in the case of professional and serious amateur cameras, the sensor works in a higher bit-depth, typically 12-bits, but some at 10-bits and others at 14-bits. In other words, the sensor is capable of recording a greater range from highlights to shadows than most monitor screens and all printing devices can display, and at some point this has to be compressed or tone mapped (see page 174). In non-Raw shooting, the camera does this, but a Raw converter and computer are a more powerful combination, have more sophisticated features, and above all, allow you to decide on the final result.

As Raw converters develop and improve, they allow more and more of the normal workflow to be conducted within them. The raw converter in Lightroom, for example, now contains an adjustment brush and spot healing tools. This makes for a more convenient, one-stop way of working, so that under many circumstances you can make a final save directly from the Raw converter window without needing to open the image again and use other pixel-editing software.

ADOBE LIGHTROOM DEFAULTS

For reference, this is the image as shot in Raw, opened as default in Lightroom with no changes. A large area is marked by the clipping warning (red pixels).

RECOVERY AND FILL

Of the various ways of approaching the translation from Raw to JPEG, this method focuses on maximum recovery of highlight clipping and an appropriate fill. The first step here, as the sun is obviously well overexposed, is to increase Recovery until the clipping warning disappears.

RESTORING SHADOWS

As the Recovery darkened the overall brightness of the image, Fill Light is increased, which has the effect of restoring the shadows.

RESULT

The combined Recovery and Fill Light adjustments have predictably lowered global contrast in the image below, so the Contrast slider is increased, creating this result.

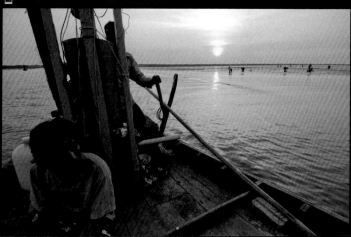

TRADITIONAL CURVES

A more traditional approach is to go straight to the Curve window in the converter. In Lightroom, four sliders below the curve target different tonal ranges, and here, the Darks and Shadows sliders have been used to raise the values of the second quarter of the range, while the Lights and Highlights reduce exposure in the sky.

VIBRANCE

Vibrance is Lightroom's control for raising saturation without incurring clipping in any of the color channels.

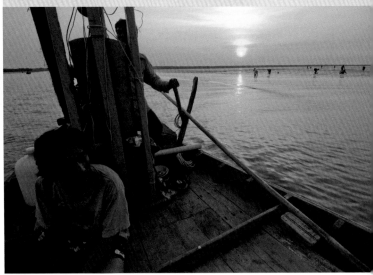

DXO

For comparison, the Raw
conversion in DxO, making
use of the before-and-after
window. All of the same
issues are addressed here
as in Lightroom, but with
different algorithms and
in a different order.

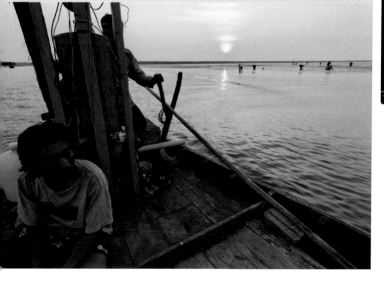

Double-Processed Raw

In principle, the full range of a high-contrast image captured in a 12-bit or 14-bit Raw file can be compressed satisfactorily into an 8-bit viewable file using a Raw converter.

The range of tools, including exposure, brightness, contrast, and curves adjustment, allow a great deal of control. However, in many Raw converters most of these are global operators—tools that work on the entire range of tones and colors in the image—whereas many low light situations have, as we've seen, sharply divided areas of brightness. The problem is often that of maintaining local contrast while holding or reducing global contrast. Photoshop's Recovery and Fill Light sliders do an excellent job of local control at different ends of the tonal scale, but in an image such as this, it may still be difficult to achieve a normal, natural-looking contrast in both the darker and lighter areas.

One way of overcoming this problem is to make two separate conversions of the Raw image and combine them later. In one version, ignore the shadow areas and concentrate on making the optimum adjustments for just the highlights and the high middle tones (what Photoshop calls Highlights and Lights). In the second, do the reverse: concentrate only on the shadows and low middle tones (in Photoshop Shadows and Darks). This method borrows some techniques from multiple exposure blending—which normally requires a tripod (see pages 166–173)—but is well suited to single-shot handheld photography.

In normal Raw processing, and indeed in all normal Curves and Levels adjustments, the operations are biased toward the mid-tones. The most common of all adjustments to a histogram is a shift with its center in the middle. Points on the histogram or curve at a distance from the center are correspondingly weaker, with the shadows and highlights being affected least of all. Even if the center point of a shift is taken from lower or higher in the curve, the same principle applies. Global operations, which is what these are, affect the parts of the image that are usually the most important—the mid-tones—and have the great advantage of being easy to understand, and are realistic in effect. However, if as in the image here, the important areas are in the shadows and/or highlights, it may be better to treat them separately.

Note that local operators such as Photoshop's Recovery and Fill Light adjustments are designed to tackle just this problem, and are very effective. They do, however, have one potential drawback, which is that because they work on local areas of pixels, they are not completely intuitive and can create unrealistic effects, particularly if aggressively used. The example above right shows what can happen.

Having made the two versions of the same image, the next step is to combine them. Here, contrary to what you might expect, there is a strong argument for doing this by hand with a large eraser brush, rather than procedurally. There are two reasons for this. First the circumstances for choosing double-processed Raw are usually when you have spatially well-defined areas, which are therefore easier to choose with brushwork. Secondly, procedural blending methods do not discriminate between which areas of the image are adjusted.

Finally, more recent versions of Aperture and Lightroom (and Photoshop as they share the same Raw processing algorithms) allow for an increasing level of localized adjustment.

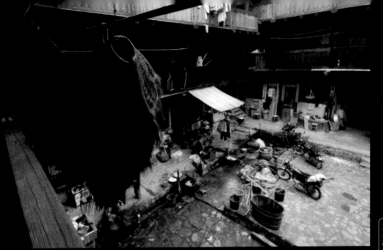

BEST SINGLE RAW

The problem in the image above is that there is interesting detail in the straw raincapes hanging close to the camera, yet even using Recovery and Fill in the Raw converter fails to do justice to this while holding the bright reflections in the tin roof awning beyond.

RESULT

The combined Recovery and Fill Light changes have predictably lowered global contrast in the image below, so the Contrast slider is increased, creating this result.

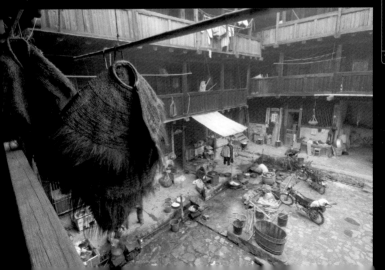

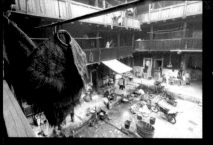

LIGHT

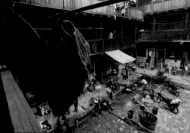

DARK

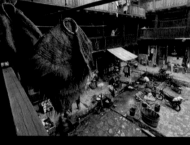

FINAL MERGED RESULT
The result, equivalent (though by very different means) to traditional darkroom print-dodging.

DUAL CONVERSION
Instead, two Raw conversions are made, one concentrating only on the raincapes, the other only on the scene in the courtyard beyond. The darker version is pasted over the lighter, and partially erased with several strokes of a brush set to 40% opacity. This manual blending works because the area that needs treatment is well-defined and localized.

This began with a simple but effective spot-removal tool, but has now advanced to brushes that allow you to select specific areas or elements of an image and apply a whole variety of adjustments—tonal, color, contrast, saturation, and so on. Furthermore any amendments you make are non-destructive, living the original data left untouched. Using the adjustment or quick brush in this way obviously saves time and speeds the workflow.

Lightroom adjustment brush

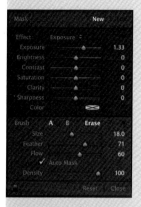

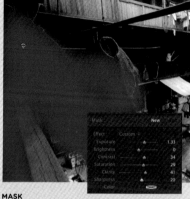

ADJUSTMENT BRUSH

Lightroom's adjustment brush provides a good selection of possible amendments, which can be applied to specific areas of the image. Brush controls, too, are flexible, allowing you to set brush size, feather size, flow, and density.

MASK

Having selected the brush type and size, paint over the area you want to adjust. As well as making the adjustment, the brush also creates a mask overlay indicating the area affected and the density.

FINAL RESULT

Here's the adjustment clearly showing the lighter rain capes. At any point you can go back and fine-tune the adjustment. As well as increasing exposure, I also increased Clarity, Saturation, and Contrast to bring out their texture.

Handheld HDRI

High Dynamic Range Imaging (HDRI) is the technique in which a series of different exposures, all of the same subject, are combined into a single, special file format that can encompass a much wider range of tones than a normal JPEG.

We deal with this more thoroughly in the next chapter, from page 158 onward, because it demands that all the image frames are in perfect register. This naturally makes it a technique for tripod shooting. However, recent improvements in automatic image alignment and in DSLR camera design now make it feasible without a tripod.

In a way it is inconvenient to split up the subject between chapters, but unavoidable given that this is a handheld possibility, albeit specialized. For now, here is a brief summary of HDRI. Shooting a sequence of identically composed images that vary only in the shutter speed allows you to cover a potentially huge range of brightnesses. In this form it is, of course, useless, as it is spread across several images. However, there are now a number of special image file formats that can contain mathematically all the information in a single file. Known as 32-bit floating-point formats (see page 172 for a more detailed explanation), they can encode an almost infinite range of brightnesses, from deep shadow to details of light sources. As ordinary camera sensors are incapable of capturing such a wide range in one go, the only practical possibility is to take a number of frames and then combine them into a single HDR file. This file must then be processed further in order to be able to produce a "normal" image file that can be viewed on a display monitor or in the form of a print, and this procedure, known as tone mapping, is discussed on page 174.

As each frame should ideally be in register for this to work, HDRI has been very much linked to tripod shooting. However, software that can generate HDR files from a sequence, including Photomatix Pro, Nik HDR Efex Pro, and Photoshop now includes an automatic alignment feature, in which the images are analyzed for content and then shifted slightly in relation to each other as necessary. There are limits as to how well the auto-alignment can succeed, but there are no real difficulties with up to several pixels misalignment.

This brings us to the second part of the equation. One alternative to fixing the camera on a tripod in order to shoot the sequence is to shoot very quickly, in a continuous burst. This minimizes the risk of moving the camera between frames. Some DSLRs have an auto-bracketing function, and this can be turned into a useful way of shooting an HDR sequence. In the example here, the exposure bracketing was set up in advance with a Nikon camera. The highest step possible between frames is 1 ƒ-stop, and the maximum number of frames is nine. While 2 ƒ-stops is generally considered the most useful step between frames for generating an HDR file, 1 ƒ-stop across nine frames gives a total range of 8 ƒ-stops, which is perfectly adequate for most situations. Setting the camera to Continuous high-speed mode allows a burst of nine frames in as little as two seconds (this depends on the lighting conditions, as slower exposures add to the overall time). There should be little problem in holding the camera on the target for this short time, particularly if you are using a vibration-reduction lens. The main limit is the slower shutter speeds, with the risk of camera shake.

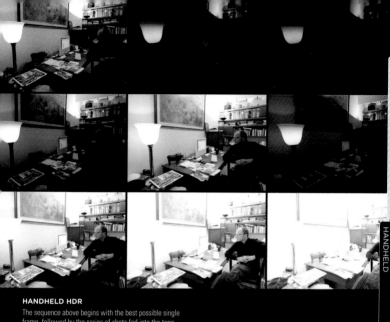

HANDHELD HDR

The sequence above begins with the best possible single frame, followed by the series of shots fed into the tone mapping tool. On the right is the aligned and mapped result.

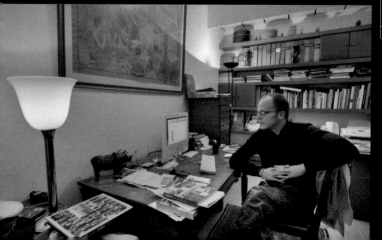

Pseudo-HDR

Some HDR software, notably Photomatix Pro and HDR Efex Pro, although not the current Photoshop, will import single Raw images for tone mapping.

This is not, of course, true HDR, in that the range in a single Raw comes nowhere near the dynamic range that can be captured in a sequence of different exposures. Nevertheless, what makes this technique worth considering in low light is that the tone mapping procedures are sophisticated and powerful, and can often recover more from the shadows and highlights, as well as emphasizing local detail, than a normal Raw converter.

The example worked through here is processed in Photomatix Pro, which converts a Raw file into a pseudo-HDR file. In fact, the dynamic range of a Raw file depends only partly on the bit depth (typically 12-bits or 14-bits per channel). The file format at these bit depths is capable of storing a considerable dynamic range, but in practice this is much less, and is limited mainly by the sensor design, and specifically by the amount of noise present in the shadows. We'll see more of noise in the following pages,

but the practical limit to the dynamic range of a single capture is the "noise floor," as it is called. This is easy to demonstrate if you open any image containing significant shadows in a Raw converter. As we saw on pages 106–109, modern Raw converters have ways of recovering information at both ends of the scale, but if you simply raise the exposure slider at a particular level you will simply be revealing noise in the shadows, not real detail. This is the "noise floor" and sets the lower limit. The upper limit, naturally, is set by full exposure, which clips highlights to pure, featureless white.

As always, each image is different and specific, and has its own needs, and this is particularly so with low light in which the shooting is usually pushing the limits. This photograph, shot at night on board a Thai fishing boat certainly presents a technical challenge. The only light for the captain at the wheel was a single bare lamp, but I liked the starkness of the lighting and the extreme play of light and shadow. Nevertheless, there was some doubt as to whether it would be possible to make a printable image.

JPEG ORIGINAL
The accompanying JPEG shows the image as shot —not very promising. I always shoot Raw plus a basic JPEG, the latter for quick preview and mailing purposes.

Photomatix Pro

Settings for processing exported files

You are about to export a single file to Photomatix Pro.

(If you wish to create an HDR image or to fuse exposures, then cancel and select bracketed photos for the export instead of a single photo.)

☑ Automatically re-import into Lightroom library
☑ Stack with selected photo

File name: Thai Fishing Boat

Output Format: TIFF 16-bit

Cancel Export

Using Photomatix Pro as a Lightroom plug-in is convenient for workflow. Exporting a single Raw file from Lightroom to Photomatix delivers this message.

Photomatix Pro now comes with a series of preset options as well as keeping all the individual controls. This is the result using default Tone Compressor.

Even with the many controls possible, no single tone mapping is ideal, and I decide to go one step further with this technique, and make more than one tone mapped version, with the intention of combining them later. In this second version, the default Details Enhancer settings lighten the shadows.

Noise in the smooth shadow areas on the left of the image continues to be a problem. For safety, I make a third version, this one aimed entirely at giving the least noise in these areas, ignoring the effect on the rest of the image. Shadows Smoothing is increased to the maximum under the Miscellaneous tools.

The three versions are combined in Photoshop, using layers, and hand-brushing with the Eraser. The main preferred version is on top, with the lighter open-shadow version underneath. The interior of the right window, and part of the center window behind the man's head are brushed through to reveal more detail. This done, these two layers are merged (Merge Visible), and the noisy areas in the shadows, particularly at left, are brushed away to reveal the less noisy version underneath. Finally, the layers are flattened.

Lightroom

The man's face appears too blown out and pale. The image is opened in Lightroom and using the Adjustment Brush in Color mode a warmer glow is applied to his face.

Lightroom's new noise algorithm offers a great level of control. I can significantly reduce the noise in the darker shadow regions, while holding detail in the man's face—by far the most important element in the photo.

The final result is a major improvement on any normal method of Raw processing.

Types of Noise

Low light photography supplies the conditions for potentially noisy images. Indeed, there is no escape from the problem, because the two practical circumstances that create the most noise are high ISO settings and long exposures.

Substituting handheld shooting for locked-down and vice versa simply exchanges different causes for the problem. And a problem it is because, while it invites comparison with film grain, it is aesthetically much less agreeable. The aesthetics of imagery are, of course, largely a matter of taste, but to date no photographer to my knowledge has chosen to use noise in a deliberate and positive way. With film, on the other hand, many photographers used the grain pattern from high-speed emulsions or enlargements of sections of film for texture and grittiness.

To understand why this is so, and also to help decide what actions to take in suppressing and removing noise, the purpose of these pages is to explain how noise originates and to examine its appearance in detail. Both film grain and noise are artifacts, but have different causes. The graininess of film is related to granularity, the random visible texture in a processed photograph that comes from the black silver grains from which the image is constructed (in black-and-white film). Fast films achieve their high sensitivity partly by increasing the size of the light-sensitive grains. The image in processed black-and-white film is in fact a mosaic of black silver grain clumps in a clear matrix, and so grain clumping is integral to the image. It is for this reason that film grain has usually been tolerated and even exploited for its graphic effect. One of the very few, or only, useful effects of noise is in suppressing discretization effects, such as banding.

However, even this is better achieved for a more agreeable result by adding Gaussian noise, which has a clustered appearance.

With digital noise, the situation is different as in principle digital images are "clean." In practice, at low sensor sensitivity (ISO 100 to 200) and with plenty of light, the results are also clean. The appearance of noise in an image can be considered a question of the efficiency of the sensor and the way the signal is processed. A close analogy is audible noise on a sound signal—crackling over a piece of music. Put another way, a digital photograph with less noise is more true to the original image projected by the lens, while a film photograph with less visible graininess simply has a tighter structure. The availability of numerous software filters to add the effect of film grain attests to its appeal, despite the dubious underlying logic.

There are several causes and therefore types of digital noise, but fundamentally it has to do with sampling errors. Photons of light are random, and the job of each photosite in a sensor is to convert them into electrons, which are then counted at the end of the exposure in the readout. Clearly, the more photons that fall across the sensor, the lower the sampling error will be. When it is darker, relatively few photons strike, so each has a greater effect on the photosite it affects. The upshot is that in shadow areas there is less chance that the photosites will make an accurate representation. This kind of noise, sometimes called "photon noise" may not be a problem if those deep shadow areas remain very dark, but opening them up in post-production will reveal them.

There are two ways of improving the photon count from dark areas. One is to

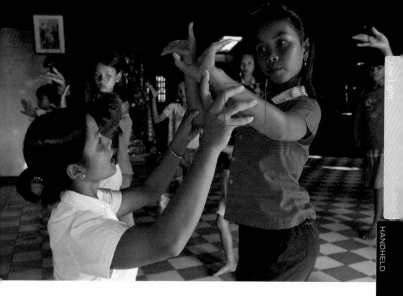

increase the sensitivity of the sensor, the other to leave the sensor exposed to the light for longer so that more photons strike and a better average can be made. These two solutions, as you can see, are why the second half of this book is divided into two chapters: handheld for higher sensitivity and locked-down for longer exposures. But each of these introduces another kind of noise.

Increasing the sensitivity of a sensor is done by increasing the gain of the readout amplifier. This is what happens when you dial up the ISO setting, and as in any electrical system, more amplifier gain means more noise, like static in a radio signal. Indeed, amplifier noise is the main culprit in the readout. This kind of noise is sometimes called "amp noise" or "readout noise" or "bias noise." Unlike photon noise, it is repeatable and predictable. As the only significant variable is the amplifier gain, this kind of noise can be treated by making a "noise

DETAIL AND NOISE

The blue box indicates an area of sharp focus and relative light where it is important to check for noise.

profile" of a particular camera at a specific ISO setting, which we'll see in action on page 154–157.

A third kind of noise is known as "random noise," which in a sense is a catch-all term for the unpredictable and unrepeatable differences in the timing and behavior of different electronic components. It tends to increase with fast signal processing, and it is difficult to predict how much it contributes to the overall total. Advanced cameras usually take some internal steps toward suppressing it.

As mentioned above, increasing the exposure time is the other solution, but this brings into play another major contributor to noise, known as "dark noise." This is caused by imperfections in the sensor, and also by the addition of electrons to the photosite

Luminance noise

Original

luminance channel

generated by heat. In principle this can be reduced by cooling the sensor (as happens in astrophotography), but this is impractical in a normal camera. As a rough guide, a temperature increase of around 6–10°C doubles the amount of dark noise. Fortunately, this kind of noise is independent of the image, meaning that if you were to follow a long exposure with an identical second exposure with the lens cap on, you would have in the second frame an exact record of the same dark noise, which for this reason is also known as "fixed-pattern noise." This is the principle of "dark frame subtraction" which advanced cameras use. Dark noise also accumulates predictably over time, so that an exposure twice as long will have more or less twice the amount of noise. Practically, this is an issue for tripod photography rather than handheld, but it seems more convenient to include it here in this general overview of noise.

In terms of appearance rather than cause, there are two main types of noise: luminance,

and chrominance. Luminance noise appears as tonal fluctuations, and is usually the most prominent. In digital imaging, color actually contributes relatively little to the content, and you can check this for yourself by taking a noisy image in Photoshop and converting the Mode to Lab (*Image > Mode > Lab Color*). Lab color space uses a luminance channel and two color channels, a (red/magenta to green) and b (blue to yellow). Zoom in to 100 percent on a noisy part of the image—in a relatively featureless area such as sky or flesh. Go to Channels and select each of the channels in turn. You will see that most of the noise— indeed, most of the subject detail also—is in the Luminance channel. Chrominance noise is less prominent, though where it does exist it is usually more disagreeable. It is related to the Color Filter Array over the sensor that interpolates the color information of the pixels; the "wrong" pixel information from noise tends toward one of the color channels.

In addition to all of this, noise goes beyond physics and into perception. This

a channel b channel

is extremely important when it comes to the reduction or removal of noise, and goes back to the definition of noise as an artifact. Even if noise exists in an image, we have to recognize it as such, and how does the eye and brain do that? Noise is random texture (spatial variations of tone and color), and at 100 percent magnification the only way to distinguish it from real subject detail is perceptually. This becomes hugely complex, as the brain must use familiarity, context, and expectations to decide. What this means is that total noise removal from detailed areas of an image (where the level of detail is similar to that of the noise frequency) cannot be automated. In other words, all noise reduction needs your guidance as the user.

Artifacts

Taken from its original meaning of a man-made object, an artifact in imaging is a visible data error introduced into the image by the process. It is thus separate in origin from the scene in front of the camera, and is a defect. Aesthetically there may be reasons for wanting to keep, alter, or enhance it, but from the point of view of the signal that generates the image it is an intruder. Both film grain and digital noise are artifacts. Analyzing the source of these artifacts for any particular image makes it possible to reduce their appearance without overly damaging the "true" image.

Noise-Reduction Software

So far, I've concentrated on how noise occurs, what it looks like, and the problems of detecting it. With all types of noise-reduction software, there are two principal steps.

The first is detection, selecting those pixels considered to be rogue artifacts. The second, which we'll now look at, is the procedure for replacing them. At pixel level, noise is not simply removed, because that would leave a pattern of "holes," whatever their color. It has to be replaced with values that blend it into its surroundings. The simplest way is to use a blurring filter, which has the effect of smearing the pixel values over a chosen radius. A Gaussian Blur filter is the standard, default means of digital blurring, although for noise removal it is not necessarily the best choice. It works by averaging across the radius selected and, in the case of noise, pixels that are very different in tone from their surroundings may not smear them completely. A Median filter, however, works by selecting the most representative pixel in the group. So, for example, if in a selected area there are just black-and-white pixels, but slightly more of the black, a Gaussian filter will return a darker-than-average gray, while a Median filter will return black. The downside of a Median filter is that it can produce an artificial-looking "plastic" texture.

In either case, blurring by its nature destroys detail and reduces resolution, one of the essential problems of noise reduction. There are other methods. One is frequency analysis, using the Fourier transform, in which the image is converted into frequencies that are then searched for structures that do not conform to standard representations of edges and texture patterns. This method is also flawed, though, as frequency analysis sometimes incorrectly assumes patterns when none are present in reality, and so overcorrects by introducing strange textures. A more advanced form of frequency analysis uses wavelet transform, which enables the noise reduction to adapt to different noise conditions in different areas of an image.

As we saw on pages 10–13, noise is intimately related to de-mosaicing (the standard procedure that all Raw converters have to apply in order to reconstruct the colors from the Bayer filter over the camera's sensor). So, better ways of de-mosaicing, meaning more sophisticated algorithms, can significantly reduce noise by doing a better job of identifying it. A good example of this is the latest version of Lightroom, in which the newly developed de-mosaicing algorithm searches for patterns and consistencies. In this way it more easily finds the inconsistencies that represent noise, and suppresses them rather than enhances (which is what primitive Raw converters do).

The blurring problem is one aspect of a more fundamental issue that I already touched on—how to distinguish and remove noise only from the areas where it is objectionable. Ultimately this is a personal, subjective assessment. One researcher's comment was "one person's noise is another person's signal." And, as Jim Christian, Noise Ninja's developer, explains, noise reduction is essentially heuristic, meaning the methods work largely by trial and error. In the end, whatever noise-reduction method you use, you should be able to choose where on the image it is applied. Fortunately, one common principle applies to most viewers and most images, and this is that noise is most apparent in areas of an image

Noise Ninja

The default settings. As the window shows, the camera and ISO setting has been recognized, and the preloaded profile applied.

Original image

Luminance		
Strength		20
Smoothness		10
Contrast		10

The default settings can now be checked and tweaked according to taste and the image, using the Noise Ninja recommended procedure, as follows. Step one is to raise Strength to maximum.

Luminance		
Strength		20
Smoothness		0
Contrast		10

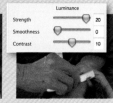

Smoothness is then set to zero.

Luminance		
Strength		20
Smoothness		2
Contrast		10

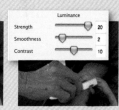

Smoothness is raised until just below the point where speckling becomes noticeable.

Luminance		
Strength		12
Smoothness		2
Contrast		10

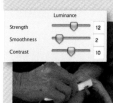

Finally, Strength is lowered until the balance between detail and smoothness is to your taste.

USM amount		105
USM radius		1.0

Sharpening, always intimately connected to noise, is then adjusted to taste.

DETAIL AND NOISE
The blue box indicates an area of sharp focus and relative light where it is important to check for noise.

that are otherwise smooth and lacking in detail. This becomes obvious when you examine an image such as this, which contains the four-way contrast of in-focus detail, out-of-focus detail, in-focus featureless subject, and out-of-focus featureless subject. Well-designed software can locate otherwise detail-free areas and apply more aggressive noise reduction to these, while protecting areas of fine detail. There are limits to how efficiently this can be done, so that it is important to add your own user decisions to the process. Some noise-reduction software allows this (such as Lightroom via its Detail control), but even if not, you can at least use Layers or some other non-destructive method to fade or restore the filter's effects selectively. Selective sharpening in one form or another is essential.

While the better programs apply noise reduction selectively, the way in which they do it is not always transparent, meaning that you are largely taking the developer's word for it that this is being handled efficiently. Until you have settled on one program and use this regularly, it remains important to check the results of the filter, as always at 100 percent. Again, some programs facilitate this (Noise Ninja, for example has a single button that toggles backward and forward between the uncorrected and corrected states), but if not, it may be worth running the noise reduction on a duplicate layer if the filter is available as a Photoshop plug-in, or copying the corrected image onto the uncorrected original in Photoshop. Toggling the upper layer off and on is effective at showing the results, detail by detail. Areas that you feel have been treated too aggressively can then be easily retouched by partial erasing.

As a result of the many variables in the creation of noise, the different ways of reducing

Case study:
ISO 1000 noise reduction

This section of a shot, of a small squid fishing boat on a sandbank in Thailand, is very much on the edge of technical acceptability. Taken handheld from a moving boat well after dusk, it was one of the very few of a set of 16 frames in which the main subject was sharp. The shutter speed was 1/8 sec, which was highly optimistic shooting at 93mm EFL (even though this was a Nikon Vibration Reduction lens). The sensitivity was set to ISO 1000, which always delivers pronounced noise. To hold the color of the green fluorescent striplight (used for attracting the squid), I took the precaution of underexposing the rest of the image, which prevented clipped highlights but laid up trouble later for noise. The Raw converter would certainly be able to pull up the shadows, but at the cost of a very noisy image, as the noise is more pronounced in the dark shadows.

Lightroom

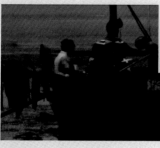

Lightroom has a powerful noise-reduction algorithm, and levels of control include both Luminance and Color sliders. The Detail sliders are crucial in allowing you to apply more or less noise reduction to the all-important areas of the image that contain detail.

Neat Image

DETAIL AND NOISE

The blue box indicates an area of sharp focus and relative light where it is important to check for noise.

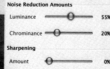

AUTO PROFILE / MANUAL SETTINGS

The noise-reduction procedure in Neat Image begins with Auto Profiling. The program automatically seeks a smooth area, in this case sky. The software also provides manual levels of control to fine-tune noise reduction.

it, and its perceptual nature, it is hardly surprising that there are many software applications for dealing with it, each with its own characteristics. As each requires user input, making comparisons is unreliable, not to mention time-consuming. Here we show a few cross-platform programs. Do not take the comparisons shown here as absolute references—the differences have as much to do with the particular images and my own choices in applying the effects as the design of the software.

Noise reduction introduces a workflow issue, because of the different approaches taken by different software, and this is particularly crucial if you are shooting Raw. If you are satisfied with the noise-reduction performance built into your primary Raw converter or image-editing program, then the decision is straightforward—simply apply it during the Raw conversion or, if the image is a JPEG, as soon as you open it. Whatever means are used by the software

to judge and then reduce noise, it works more reliably when the image has been least altered.

However, the several independent noise-reduction programs, as we've just seen, lay claim to doing the job better. Before anything else, then, it is important to try out the various choices and decide for yourself which you prefer. There is a strong element of personal preference in this, as noise reduction is not a "clean" procedure. It always carries some side effects, and there are trade-offs between efficiency. Speed of processing in batches may be more important to you than spending more time on individual images. And, even taking both these factors into account, you are likely to find that some images respond better to one noise-reduction software than others.

As with blur repair, there are two stages followed by noise-reduction filters. First, the noise has to be analyzed. Then a particular

Noise Ninja

The image as opened in Noise Ninja. At this stage, the profile is either loaded from the library, or created from analyzing the image.

The result following the procedure described earlier; increasing Strength to maximum, raising Smoothness just below the point at which speckling becomes obvious, then reducing Strength to taste.

algorithm has to be applied that reduces the variation in tone and color between the noisy pixels and their neighbors. Different noise-reduction software has different algorithms, and this more than anything accounts for differences in the final image appearance. There is an element of taste and judgment here, both on the part of the software developer and the user. Complete noise removal from a zone of the image may also give it a plastic-like, artificial texture—or rather, an absence of texture.

Another side effect is softness, because reducing sharpness is inevitably part of noise reduction. Distinguishing between featureless, smooth areas and those containing detail is difficult to automate.

Noise-reduction software that depends on camera-sensitivity modules prepared by the software manufacturer and loaded up in advance absolutely needs the purest image

data to work on. There may well be a dilemma here, in that the noise-reduction software (Noise Ninja is one example of this kind) will work better if you do little to the image during the preceding Raw conversion, whereas Raw conversion now offers more and more attractive procedures for optimizing the image in other ways, such as lightening shadows and recovering highlights. My best advice is to run a few tests, contrasting minimum-alteration Raw processing against full alteration, both followed by noise reduction. Judge the results at high magnification, at least 100 percent. Note that "dark frame subtraction" procedures, being repeatable, are best performed either in-camera or with the Raw converter, and specific noise-reduction programs such as Noise Ninja or Neat Image work very well afterward to take care of other kinds of noise.

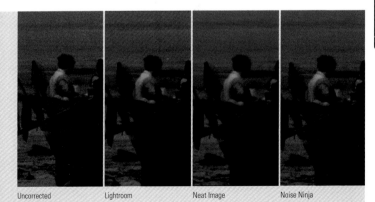

Uncorrected Lightroom Neat Image Noise Ninja

NOISE AND DETAIL
The results, compared side by side. This shows that it is less a matter of better or worse, and more a trade-off between less noise, and maintaining realistic detail.

Adding Flash

Strictly speaking, low light photography is about shooting without the aid of photographic lights, of which even a built-in camera flash is one.

Nevertheless, it really depends to what extent you use it to shape the final image, and among the most common techniques is to add a relatively small amount of flash to the end of an exposure otherwise metered for the ambient conditions. This rear-curtain flash technique is well-established, and most digital SLRs have a setting that allows it. Briefly, the flash is computed to fire at the end of the exposure, as the final curtain of the focal plane shutter is closing, rather than at the beginning or during. This is an important distinction for any shot that is at a relatively slow shutter speed (say, slower than 1/30 sec), because motion blur, either from the camera, or the subject, or both, will create streaking, while the flash freezes everything sharply. Clearly, if the flash is at the start, the streaking will continue on from this, and if it is somewhere in the middle of the exposure the image will be even more confusing, with streak tracks on either side of the sharp details. The strongest case is for the flash terminating the entire exposure— most images are more legible this way.

The principle of combining low light streaking with a flash-frozen punctuation is that the two quite different visual effects complement each other. Arguably the most effective balance is when the main component is the low light streaking, with the flash providing just enough exposure to "close" the image and make sense of what might otherwise be moving details that are hard to understand. Personal preference, of course, is a major factor, and the only way to decide on your ideal combination is to try out several for yourself. There are clearly many permutations of shutter speed and

flash strength, and these are affected also by the situation and content. To list just a few, there is the amount of subject movement, the basic readability of the subject (some things just don't make sense unless they are sharp and clear), whether the subject is light in tone against a dark background or the opposite, and the color balance of the ambient lighting (orange tungsten makes a strong contrast with white flash). If there is time to prepare, run a few different combinations of shutter speed and flash amount to see which appears to work best. There are usually several choices of camera setting to balance and combine these two; there's no reason to list these here as they vary by make and model and are fully detailed in the camera's instruction manual.

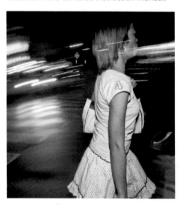

REAR CURTAIN FLASH

Here, the on-camera flash is used at full strength (exposure bias 0.0) and slow speed (1/13 sec), so that the figure is well exposed, while car headlights behind are bright enough to create streaking patterns from the pan. ISO 1600, ƒ/6.3, and a wide-angle 18mm EFL.

Flash positioning

Depending on positioning, flash units can make dramatically different-looking images.
Here are some alternate results from the same shot, and plan views of the setup required.

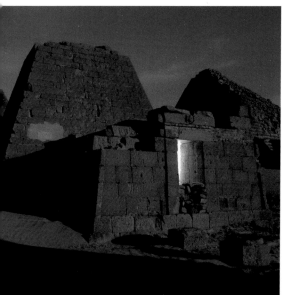

**REMOTE FLASH
FOR EFFECT**

Off-camera and triggered
remotely (or as in this case
held by a companion out
of sight), flash can also
be used as a practical light,
simply for effect. Here, a
single flash is used to add
a little atmosphere to a
moonlit shot of pyramids.
Exposure time 30 sec at
$f/2.8$ and ISO 400.

LOCKED DOWN

Low light photography embraces many subjects
and situations, from highly charged downtown city
streets at night to silent evening landscapes.

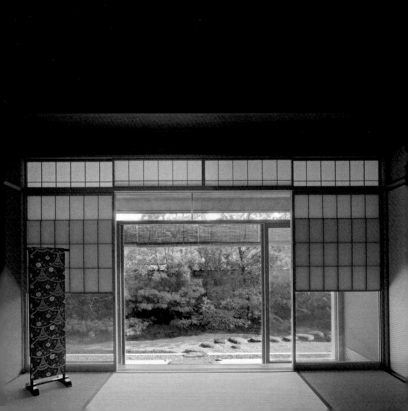

In the last chapter we looked at what is for the most part a reportage approach to photography, suited to subjects that move, unpredictable moments that need quick reaction, and a way of working that is light on equipment and carries a percentage of failed shots.

But when the main subject remains still, or reasonably so, and you have more than a few seconds to get ready for a shot, the more reliable technique is to use a tripod, or some equivalent means of locking down the camera. This simple act opens the way for long exposures that can handle almost any light level, and some guarantee that the shot will be technically fine, meaning sharp, accurately exposed, and with noise kept under control. Some of the newest technical developments, especially in the processing stage with techniques like HDRI (High Dynamic Range Imaging) can make a quite remarkable

difference, enabling results that would have been inconceivable without digital technology.

There is, as we'll see, rather more technology involved (or at least available to us) in locked-down photography than in handheld, and more of it concentrated in post-production. Nevertheless, while the process of shooting is certainly more reliable than handheld, it demands its own particular technical proficiency. There is more equipment to carry in the form of the tripod, and that alone establishes a different approach. In place of the physical attention that handheld photography demands, there is care in tripod management and protection from vibration—demands that have not, of course, changed throughout the history of photography. What is new is the need to plan ahead at the time of shooting, making exposures that will in many cases undergo considerable post-production.

INSIDE TO OUT
When shooting interiors with a view through to a bright exterior, one option is to lock the camera to a tripod and take several shots of varying exposures to composite later in editing software.

Tripods

However proficient you become at handheld shooting, a solid, locked camera support is still the most secure technique for shooting.

It is essential for any lighting condition that puts the fastest shutter speed below the safe limit for the combination of lens focal length and hand steadiness. Tripods, in various forms and designs, are the basic mechanical support. Rigidity is paramount, though for ease of carrying around this often has to be compromised to some extent by the tripod's portability. Increasingly, new materials, such as carbon fiber and basalt fiber are being used, which have a higher strength-to-weight ratio than traditional metal alloys, so are light, while remaining rigid, but are considerably more expensive.

The standard portable design has telescopic legs, usually in three sections, a rising center column for fine adjustments, and a fixed angle of spread. There are many variations as manufacturers compete for attention. A variable angle of spread has advantages in that you can accommodate different surfaces, but this usually involves an extra set of bars with sliding collars (these are standard for professional filming and video, where weight is not such an issue as in still photography). An alternative is a second fixed position (Gitzo use this extensively). A wide spread can also be useful for a lower camera position, and better stability in windy conditions.

Tripods

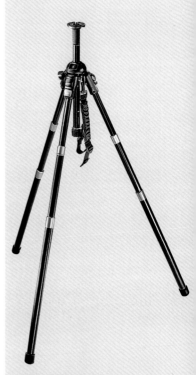

QUICK SETUP TRIPOD
The Manfrotto 458B Neotec tripod is fast and easy to use, with an innovative Neotec rapid opening and closing mechanism—just pull each leg downwards to open and automatically lock it in any position, with no screws, knobs, or levers to tighten or loosen. To fold it back up again, press the release button and push the leg closed.

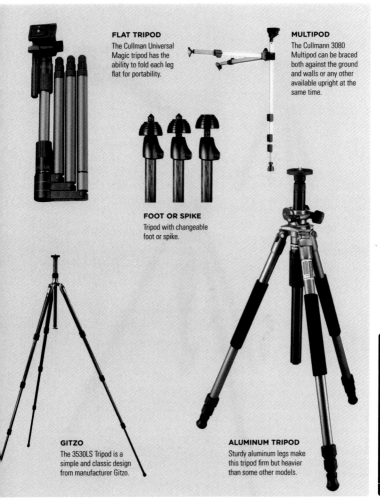

FLAT TRIPOD

The Cullman Universal Magic tripod has the ability to fold each leg flat for portability.

MULTIPOD

The Cullmann 3080 Multipod can be braced both against the ground and walls or any other available upright at the same time.

FOOT OR SPIKE

Tripod with changeable foot or spike.

GITZO

The 3530LS Tripod is a simple and classic design from manufacturer Gitzo.

ALUMINUM TRIPOD

Sturdy aluminum legs make this tripod firm but heavier than some other models.

Tripods continued

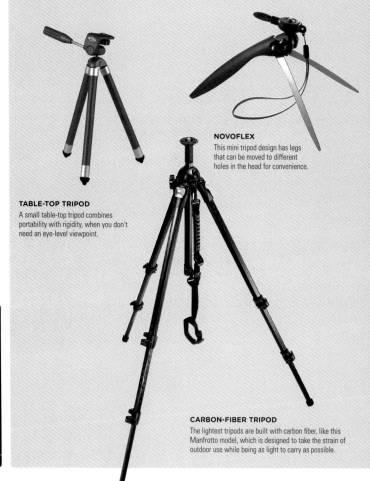

NOVOFLEX
This mini tripod design has legs that can be moved to different holes in the head for convenience.

TABLE-TOP TRIPOD
A small table-top tripod combines portability with rigidity, when you don't need an eye-level viewpoint.

CARBON-FIBER TRIPOD
The lightest tripods are built with carbon fiber, like this Manfrotto model, which is designed to take the strain of outdoor use while being as light to carry as possible.

CULLMAN MOSKITO

A portable mini-tripod which features a two-way pan head.

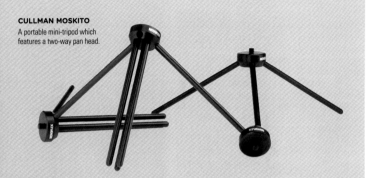

MARKET INNOVATION

As the behavior and tolerances of synthetic materials are better understood, more and more versatile products are emerging, like the Gorillapod, which has flexible legs that can be bent around any convenient support, or used in traditional mini-tripod form.

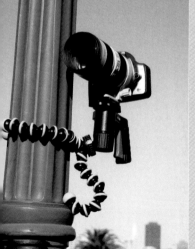

Tripod Management and Techniques

There is a surprisingly big difference in stability between a tripod used well and one set up inefficiently. Tripods obey the laws of mechanics, and the aim in setting up is for maximum stability.

This is largely a quest for rigidity, and there are a number of ways you can help. A tripod's telescopic legs are more stable when compact than when extended, which means that a tripod at its most compact on a solid raised ledge (or other surface) will be steadier than the same tripod extended from the ground. Equally, when you extend a telescopic leg, extend the thicker sections before the thinner ones.

The surface on which the tripod is erected also matters. Outdoors, beware of sand and any loose conglomerate like pebbles. If in doubt, twist and press the feet down to make sure they are on as stable a surface as possible. Grass and earth, even though soft, can be good, provided that the feet can be pressed in—a spiked foot is an advantage. Remember that outdoors the tripod must also battle the wind, which is especially troublesome if it is gusty. Indoors, carpets are notoriously spongy and uncertain, and bare wooden floorboards can shift if trodden on, even some distance from the tripod.

The tripod is at its most stable when the head is exactly centered between the three feet which it sites above, and when the platform, immediately below the head, is level. Some models have a spirit level built into the platform. Try and level this rather than leveling only by means of the head. For the same reasons, try and ensure that the combination of camera and lens has its center of gravity over the center of the tripod. That's why long lenses have threaded mounts.

You can test the stability by gently tapping the end of the lens. Look for any

visible movement of the equipment, then repeat this tapping while looking through the viewfinder. As mentioned, you can improve the stability of the setup by lowering the center of gravity of the tripod plus camera. One additional way of doing this is to add a weight to the center; a few tripods have a hook at the base of the center column for this purpose. Hang anything you have handy, even your camera bag.

Tripod maintenance involves keeping the collars and other parts of the telescopic leg system clean, dry, free of abrading particles, and lubricated appropriately. Molybdenum disulfide and graphite are high-quality lubricants often used by manufacturers, but it also pays to find out exactly what the tripod manufacturer recommends. Also keep the joints at optimum tightness—not so tight that they are difficult to move, but without any play or sideways movement.

Tripod equipment

SUPER TELEPHOTO

This Nikon lens has a center of gravity much nearer the front, hence the support, which should be mounted onto a tripod rather than using the camera's own mount.

TRIPOD BAG

Use a camera bag to add weight and stability to a tripod setup.

TRIPOD BAG

This LowePro camera bag includes a tripod holder making carrying of a full-sized tripod far easier.

Monopods

MORE STABLE

LESS STABLE

Heads: Range of Models

There are two basic designs of tripod head, but many individual designs, and some crossovers. The most traditional is a pan-and-tilt head, with each axis of movement kept mechanically separate (roll, pitch, and yaw, if you like).

The entire assembly rotates at the base, and this can be locked, usually with a screw knob. Two locking arms each control one of the other movements. Rotation, of course, is 360 degrees, and the advantage of this tried and tested design is that small adjustments can be made in a single direction without upsetting the others. This is important if you need to level the camera precisely.

Ball-and-socket heads, normally referred to as ball heads, have become increasingly popular, partly because they can be switched between locked and completely free very quickly, and partly because they are so compact, adding very little size to the folded profile of the tripod. For situations that call for solid support at some times, but free movement at others, ball heads have a clear advantage. When slightly loosened, they are ideal for following subject movement, though heads designed for videographers have some advantages in this area.

Tripod heads

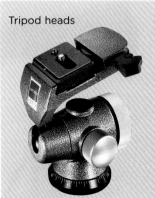

OFF-CENTER BALL
An off-center ball head allows a different range of movements from the conventional center-ball design. Here it is combined with a separate pan control.

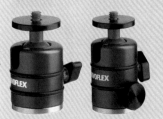

BALL HEADS
Increasingly popular for being compact and very quick to use, feature a single locking mechanism. The single disadvantage, which may not be important, is that releasing the lock means re-setting the camera completely, rather than being able to keep one or two axes aligned, as with a three-way head.

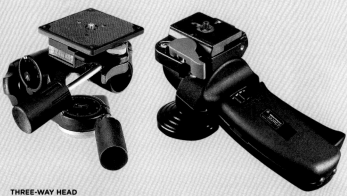

THREE-WAY HEAD
Made of light magnesium alloy, this typical three-way head offers three independent axes of motion, each with a locking handle/lever. The best brands use fluid cartridges for accurate movement with minimal effort.

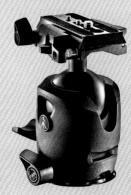

QUICK RELEASE
Quick-release systems, like this one from Manfrotto, are an essential part of any quick-response tripod shooting. The base attaches to the tripod head, and individual plates to the camera(s).

Clamps and Alternatives

Portable equipment

There are many alternative solutions to tripods for securing a camera,
adapted to different shooting situations and viewpoints.

SUCTION PAD

Activated by a U-shaped
lever, grips on any smooth
surface such as glass,
marble, metal, or plastic,
and takes a load up of up
to 6 lbs (3kg).

GROUND SPIKE

For pushing into any
ground like sand, earth,
pebbles, snow etc.
It combines with a
ball-and-socket head.

WOODSCREW

A woodscrew with ¼-inch
thread connection. Can be
screwed into beams, fence
posts, and tree stumps.

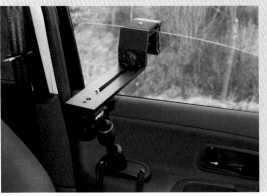

NOVOFEX CAR WINDOW ACCESSORY SET

Featuring an accessory
plate with a screw thread
for connection of a
ball-and-socket head or
other accessories. Rigidity
is achieved by the
additional support obtained
from a monopod or the
Novoflex Chestpod.

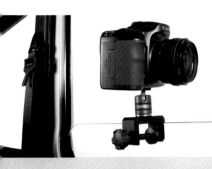

SLR SUPPORTED
Clamping to toughened glass can be surprisingly effective, even with quite heavy cameras.

CLAMP AND ROD SET
This versatile set handles all of the situations shown on this page, and more.

CLAMP AND ROD
Additional height can be achieved when a clamp is used in conjunction with a rod.

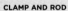

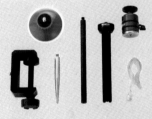

BAR MOUNT
The indent in the clamp means it can also be attached to a circular rod, like a handlebar.

Motion Blur with Tripods

Motion blur with the camera mounted on a tripod allows much greater control than when handheld, and gives two distinct possibilities.

One is subject motion blur with the camera motionless, so that the setting remains sharp. The other is smooth panning, and if you have time to set up a tripod, this assumes some kind of predictable, or anticipated subject. We looked at panning and tracking on pages 110–111, and while either works well enough handheld, using a tripod offers two advantages. One is that it frees at least one hand to operate camera controls, the other is that it allows a steadier flow of movement. In either case, subjects that have distinct blocks of tone or color, and an outline that is easy to recognize, tend to convert well into a motion-blurred image. Using a tripod makes it possible to work with quite long exposures, such as one second or more, although the mirror-up

position makes following a subject at these speeds a little unpredictable.

A word about the tripod head. Ideally, there should be enough friction to support the camera and lens without putting strain on your hands, and with enough free play in the direction of the pan to follow the target without drag effects. As most panning sequences involve horizontal movement, it usually helps to loosen the rotating axis fully, keeping the friction quite firm on the other movements. This depends on the kind of head. For instance, some ball-and-socket heads have an additional rotational movement; a good panning setup with this type is medium friction on the ball and loose on the rotation. If there is no additional rotational movement available then you will need the ball to be set looser.

One danger in tripod panning is that if the tripod itself is not level, the vertical and

Readability

This sequence of images, with a figure clad in black walking repeatedly in front of an art installation, was shot at 1/3 sec. The shutter speed was determined in advance by experiment—sufficient to show that it is a walking figure, but as motion-blurred as possible to emphasize the ambiguity of the scene. The basic problem is that the movement of the legs in certain positions (most positions, in fact) makes the figure look one-legged. In cases such as these, it is important to shoot sufficient frames for a good choice. Here, the third frame of the four "reads" best.

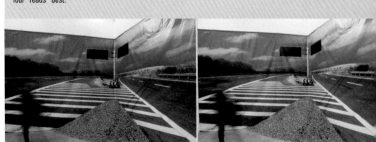

horizontal smear lines in the image from motion blur will become increasingly askew as the camera is rotated. If you have time to prepare the setup and know in advance the route that the moving subject will follow, check the moving view through the viewfinder with a quick practice run first. Another reason for checking out the path of the pan is that it may involve changes in focus and exposure. Most lenses are now autofocus, but for ones that are not, you will need to continually check and adjust the focus during the pan. Almost all modern SLRs have focusing features for just such situations as these, and can make some prediction of distance as the camera follows the subject. This is known as AI Servo on Canon cameras, for example, and can be quickly set via the camera buttons.

ENLIVENING WITHOUT DETRACTING

One practical use of motion blur with the tripod locked down is when the subject is inherently not particularly interesting. In this case, a photograph was needed of the entrance to this office, but to give it some extra interest, the shot was timed for the moment when a visitor was leaving. Setting a shutter speed of 1/4 sec made the person less recognizable, and blurred the figure to make it less prominent.

Long-Exposure Noise

As touched on earlier, "dark" or "fixed-pattern" noise is caused by imperfections and irregularities in the sensor, including, for example, uneven boosting between the individual readout amplifiers accompanying each photosite on a CMOS sensor.

It increases approximately in proportion to the exposure time, and at one or several minutes can be very noticeable. It is also enhanced by heat-generated electrons adding to the photosites, so you can expect more noise in warm weather than in cold. Because this kind of noise is related to the sensor and its circuitry and not to the image, it lends itself to fairly efficient correction. The key, however, is to record the exact pattern of the noise at the time of shooting.

Noise increases with Raw adjustments

ORIGINAL
This night shot, with a full moon rising behind pyramids in the Nubian desert, was exposed at 15 sec at an aperture of $f/3.5$ and a low ISO of 200. The clarity of the atmosphere accounts for the high level of brightness and thus relatively short exposure (see pages 34–43). Long-exposure in-camera noise reduction was on. Nevertheless, while this combination of settings works well for an image as exposed, noise problems still appear when attempts are made to open detail from the shadow areas.

Some DSLRs have a menu option to do this automatically and make an immediate reduction of the noise, and the results are usually impressive. The main drawback is that it adds the same amount of time again as the original exposure, and if you're allowing a few minutes for an exposure, this may not be acceptable.

AS EXPOSED
Noise is well suppressed with the Raw image converted to TIFF at standard settings, without any adjustment to either the exposure or the brightness.

CORRECTED
This area of the image, with an area of moonlit sand visible, shows what happens when the Exposure slider in Photoshop ACR is raised by 2 stops. The result is serious noise, which would need to be addressed in post-production.

Noise Comparison

Perhaps surprisingly, the difference between noise-reduction on and off is quite subtle, even at the long exposure of one minute shown here in this side-by-side comparison. The top pair is a comparison between on (left) and off (right). To highlight the effect, a deliberate underexposure of two stops on the aperture was corrected in Raw conversion. The lower pair is the same, save that the exposure is correct. The difference between on and off is slightly more obvious on the upper pair. More importantly, adjustments in the Raw conversion (or with a TIFF by raising the gamma in Levels or Curves) has a more damaging effect than not choosing in-camera reduction.

2 F-STOPS UNDEREXPOSED, CORRECTED IN RAW

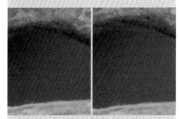

Noise reduction on Noise reduction off

CORRECT APERTURE SETTING

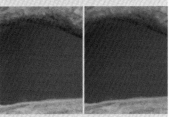

Noise reduction on Noise reduction off

LOCKED DOWN

While fixed pattern noise and, to an extent, readout noise are amenable to in-camera treatment, "random noise" is intractable.

By its nature it is completely unpredictable, and it is also difficult to gauge how much it contributes to the overall noise in any given situation. In the final image, the different sources of noise are overlaid on each other. However, there exists an effective, though time-consuming method of isolating and reducing "random noise" on a picture-by-picture basis. This is the image averaging technique, and calls for a few or several identically framed shots taken consecutively. Because it needs to be planned for, and drastically slows down shooting, it is not likely to become a standard technique. It can be performed only with the camera locked on a tripod, because the frames must be in pixel-perfect register.

The principle is that if the scene is completely still, without any subject movement, the only variable between identically exposed frames will be the random noise. Averaging the images removes this noise. In astrophotography this is a well-known technique, and it applies equally to regular low light photography. In practice, it means repeating the shot without any movements to the camera, taking special care with the tripod and shutter release. No special software is needed other than Photoshop, because the averaging is done with layers. Like Dark Frame Subtraction to reduce dark or fixed-pattern noise, it increases the signal-to-noise ratio of the image and so is non-destructive, unlike most software methods which blend noisy pixels into their local neighborhood. The noise between two frames is averaged, in effect reducing it by half in the combined image. This is more or less the equivalent of noise from half the ISO setting.

In Photoshop use the image stack Auto-Align features. First, copy and paste all the images into one layered image. An alternative is to load the layers with a script *(File > Scripts > Load Files into Stack)*. Then select all the layers and run Auto-Align to put them into register.

ENLARGEMENTS SHOW NOISE
The original, shot in sequence at ISO 1600.

Convert the layers into a Smart Object and then choose a Stack Mode. The two useful modes for noise reduction are Median or Mean. Try both, but Median has the ability to replace pixels more drastically, rather than just reducing the strength of noisy pixels. Moreover, if there has been subject movement between frames, such as branches moving in wind, or a passer-by, Median can remove them. In any case, it is worth experimenting with both to see which is the more effective for a particular image.

An alternative way to combine the multiple images is to use Photomatix, the popular HDR software. Photomatix has an Average option, which applies a median filter to a group of images.

Photoshop

In Photoshop, the same combining procedure can be achieved. It takes more steps, but is efficient. First copy all the frames into one image, as separate layers. Once the layers are merged into a Smart Object it's a simple matter of clicking *Layers > Smart Objects > Stack Mode > Median*.

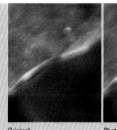
Original

Photoshop

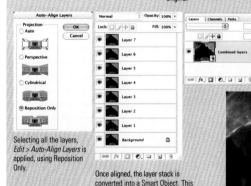
Selecting all the layers, *Edit > Auto-Align Layers* is applied, using Reposition Only.

Once aligned, the layer stack is converted into a Smart Object. This is achieved by highlighting all the layers and clicking *Layer > Smart Objects > Convert to Smart Object*.

Result

Multiple-Exposure Contrast

The high contrast caused by pooling of light is typical of many low light scenes, from a restaurant interior with spotlighting, to a city view at night.

In the days of film this meant either bringing in photographic lighting to open up the shadows and balance the contrast, or simply accepting the high-contrast result with all its accompanying loss of detail. Now, however, this problem can be solved, particularly with a tripod. For subjects in which there is little or no movement, or at least where any movement is not a significant part of the image, the solution involves shooting the same scene at a number of different exposures, with no camera movement between frames.

As we'll see over the next few pages, there are a number of ways of combining a range of exposures, but the principle is always the same— to take the best detail from each individual exposure. So, with a high-contrast scene, the exposure that best deals with the middle range will likely overexpose highlights and underexpose shadows. Once the highlights have blown, at 255 on the histogram, the sensor photosites have essentially been flooded, and there is no detail captured at all. Correspondingly, serious under-exposure renders deep shadows black (level 0), and while dark shadow areas may retain some detail that can be pulled up during processing by using Levels, Curves or a local-contrast process such as Photoshop's Shadows/Highlights feature, this will always be at the cost of increased noise. However, if in addition to the standard exposure that captures midtone detail, you shoot a longer exposure to capture shadows and a shorter exposure to capture highlights, you have effectively increased the amount of visual information you have to work with.

Another way of looking at this is that

TRADITIONAL
The best of the traditionally exposed images has blown highlights around the lights and central window.

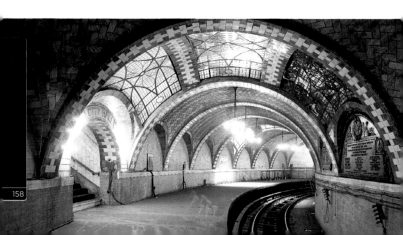

by bracketing exposures of the same scene, you are extending the dynamic range of the camera's sensor. Admittedly, this is not all in one frame, and the next steps on the computer can be time-consuming and complex, but what is important is that you have captured much more detail than would otherwise have been possible. The bottom line is that if you have the time to do this, a range of exposures is a great back-up. You have lost nothing but a few megabytes of storage space, and gained a valuable archive of visual data. The following pages detail the current ways of handling this data, including the newest, HDRI, but we can also expect future imaging software to improve. The key lies in the capture.

The procedure is straightforward, but there are ways of making it more efficient

HDR IMAGE

The result of merging several differently exposed frames shows more detail in areas that were completely blown in the example opposite.

and reliable. Clearly, the idea is not to move the camera at all between frames, and this makes a cable or remote release valuable, as well as good tripod use (making sure that it is firmly sited) and anything to reduce mirror slap, such as locking the mirror up. However, absolute precision to the pixel is not necessary. Desirable, certainly, but recent imaging software advances have made automatic alignment of images highly efficient to within several-to-many pixels.

One important alignment issue, however, is that you should vary the exposures by altering the shutter speed, not the aperture. Aperture affects depth of field, which can change the content of the image between frames, particularly as in low light you are likely not to be stopping down fully. There are two important considerations in working out how many frames and at what settings. The first is that the exposure gap between frames is short enough so that the software you use later for blending can handle them, yet not so

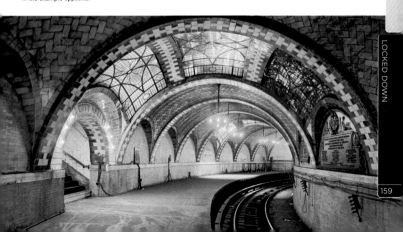

Shooting the sequence

First find (by measurement or trial and error) the shortest exposure which shows no highlight clipping. The most convenient indication is the flashing highlight warning. The shutter speed needed is the setting just shorter than this.

The first frame is the shortest shutter speed without clipping.

2 stops more.

2 stops more.

short that you clog up the memory card unnecessarily and take too long in shooting. As a rule of thumb, certainly for HDRI, 2 stops works well in most cases. One stop is safer, but usually redundant. Time and storage space are important, and many cameras have a small frame buffer, which can mean that you have to wait for frames to be processed by the camera before you can continuing shooting.

The second key consideration is to set the right limits for each end of the range. You need the shortest exposure to capture all significant highlight detail, and for this the best guide is the camera's on-screen flashing warning for highlight clipping. Nevertheless, you probably don't need every tonal detail of naked lamps. Treat these as you would specular highlights, and let them blow. This highlight clipping warning makes the shortest exposure the most convenient place to begin the sequence. From

The next frame is shot at 2 stops more exposure than this, using the shutter speed control only.

The next is 2 stops more again.

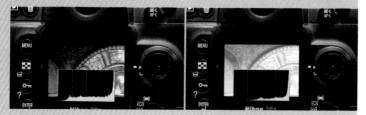

2 stops more.

The final exposure is the one that shows the darkest shadows at the midpoint in the histogram.

this, increase the exposures regularly between frames. Continue until the last exposure captures all the shadow detail that you want. Be warned that at night, because of the eye's adaptation and because the camera's LCD screen is likely to be much brighter than your surroundings, it's easy and normal to think that the exposures are brighter than they really are. As a precaution, and until you get used to doing this, continue at least one step beyond what you judge to be sufficient by

eye. In addition, check the histogram display on the camera. For the last frame, capturing shadow detail, there should be a distinct peak on the right side. Failure to capture full shadow detail is the most common problem in shooting a range of exposures, and the penalty is noise.

Manual Blending

The least technical, most personal method of blending different exposures in a layer stack is to use the Eraser brush on an upper layer, so as to reveal better exposed detail underneath.

In principle, nothing could be simpler, and it's worth saying that while Photoshop experts might treat such a non-procedural approach with some disdain, for photographic realism this is in no way an inferior technique. Indeed, with some types of image it can be more efficient too. Typically, the kinds of images that respond well to manual brushwork are those where the difference in exposure between the layers is confined to distinct spatial areas of the image. For instance, in a shot through a doorway or window from, say, a dark interior to a bright exterior, it may be fairly straightforward to select this hard-edged frame and then erase this part of an upper, light, image layer.

Brush techniques tend to be idiosyncratic, in that most people simply develop their own particular ways. It is less valuable to try and categorize all of this than to show specific workthroughs. The examples here illustrate just some ways of doing this.

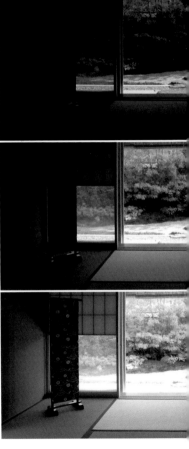

SOURCE IMAGES
The original three source images, spaced 2 *f*-stops apart.

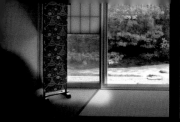

The two darker images are pasted in as layers over the lightest, so that the layers are ordered darkest at the top, lightest at the bottom.

The middle layers are erased to leave just the exterior view.

Next, the top layer is made visible, and erased to leave all but the sunlit portions of the exterior.

The layer stack after the two upper images have been selectively erased.

The final result.

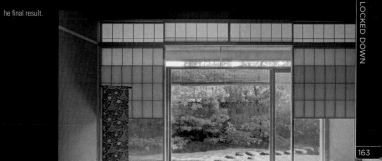

High–Low ISO Blending

Consider a low light scene in which you have plenty of static fine detail that calls for a slow exposure that will be relatively noise free, but at the same time there is some movement that you would also like to capture.

The dilemma is whether to choose a low ISO setting and put up with motion blur in parts of the photograph, or a high ISO setting which will capture the movement, but increase the noise. Remember from what we've seen of the different causes of noise that dark or fixed pattern noise is much easier to reduce than readout noise at a high ISO.

Well, there is a way of having the best of both worlds, although it takes time, requires a tripod, and works only in certain circumstances. The principle is to make two separate exposures, one at a low ISO and longer shutter speed, and the other with a high ISO and short shutter speed. The two can then be combined later, choosing only the subject movement from the noisier high-ISO image. In effect, this drastically reduces the area over which you need to apply software noise reduction.

The example here illustrates the process and what it is capable of. The first image was handheld at 1/20 sec and f/4.2 at ISO 3200. With a tripod and, using the LCD screen view of the image to help align the new shot, I took the same view at ISO 100 and f/11 at 4 sec. The post-production involved running a noise-reducing filter over the figure of the old woman, combining this and the noise-free version in register as layers, and erasing the "noisy" background from around the figure. Reproduced small-scale as most of these pictures are here on these pages, the benefits are not so obvious, but practically this meant that the image could be printed acceptably up to exhibition size.

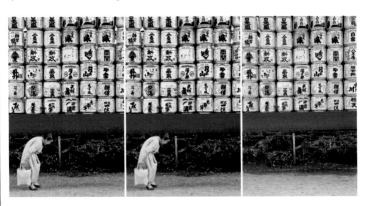

THE ORIGINAL
The original, handheld shot, ISO 3200, as shot without noise correction.

SIMPLE CORRECTION
The same, with noise correction applied using Noise Ninja (adjusted for best effect on the figure only).

TRIPOD SHOT
The second shot, taken at ISO 100, tripod-mounted.

Next, the eraser brush is reduced in size, and the erasing continued at magnification.

The first image, processed in Noise Ninja for noise reduction, is pasted as a layer over the second, cleaner image. At full scale to begin with, the surroundings are erased from the top layer using a large, soft brush.

The final result.

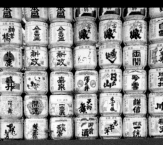

COMPARISON

A detailed comparison of the key area of the image, where the figure and background are blended. From left to right: the first high-ISO noisy image, the same image processed for noise reduction using Noise Ninja, the noise-reduced version combined with the second, noise-free image.

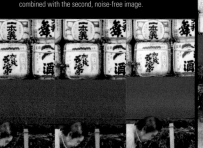

Blending Software

Currently the best-known dedicated software for blending a range of exposures is Photomatix, a cross-platform program that also handles HDR generation and tone mapping.

Although both blending and hand-tone-mapping have a similar purpose in compressing a high dynamic range captured in different exposures, the techniques are quite different. Of the two, blending is easier to understand, and the several Photomatix options follow the same basic principle as the highlight-and-shadow blending method described on page 104–105. They are, however, more refined and automated.

Compare the description here with that of HDR and tone mapping on the following pages. Both methods use the same source files. Blending, which is called Exposure Blending in Photomatix terminology, selects highlight details from the less exposed images and shadows from the more fully exposed images. These are then combined in such a way that there is a smooth, unnoticeable transition across the midtones. The algorithms used make use of weighted averages, and in one of the five procedures offered this can be shifted by the user toward darker or lighter.

ORIGINALS
The three original source images, spaced 2 *f* stops apart.

Different processing

The algorithms for each are different, and as the results always need to be judged subjectively, as to how pleasing or otherwise they are to you, it is difficult to predict which to choose. Accordingly, Photomatix offers a batch-processing option, and recommends in case of any uncertainty using this to produce a range of results. You can then choose which looks best to you.

Average – This method combines images using the same averaging formula throughout the image, regardless of whether the computed pixels are in a dark or bright area. For this reason it cannot give the dynamic range extension possible with the other blending methods, but it has a natural effect and also has the effect of reducing noise.

Fuse exposures with H&S – Auto can handle more than two images, and is designed for a "natural looking" result. As a consequence, it errs on the side of flatness, with low contrast, but this can be improved later with any of the previously mentioned Photoshop contrast-enhancing techniques.

Fuse exposures with H&S – Adjust This gives you the choice of weighting the result toward the brighter or darker end of the range of source images, and also adjusting the radius (as this is a local-contrast enhancement method). A high radius produces a sharper-looking result, at the expense of a longer processing time, but runs the risk of halo artifacts around sharp changes in brightness.

Fuse exposures with H&S – Intensive This is intended to deal with a range of source images covering a very high dynamic range. As with Adjust there are a number of adjustable settings available, including Strength, Color Saturation, and Radius. With a high dynamic range, HDR and tone mapping is likely to be a better choice.

BATCH PROCESSING

The Batch Processing window in Photomatix. For this exercise, all the options have been selected. This is also a useful technique when there is uncertainty over which of the several blending methods will be best.

Average

Adjust

Auto

Intensive (strength 0)

Intensive (strength 10)

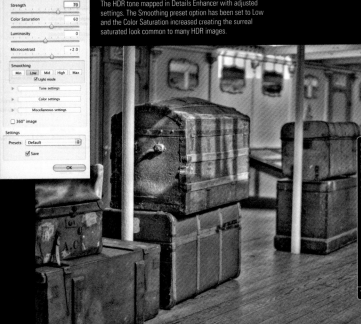

GLOBAL OPERATOR

For comparison, an HDR file generated and tone mapped using the global operator (Tone Compressor).

LOCAL OPERATOR

Also for comparison, an HDR file generated and tone mapped using the local operator (Details Enhancer) at its default settings.

ADJUSTED SETTINGS

The HDR tone mapped in Details Enhancer with adjusted settings. The Smoothing preset option has been set to Low and the Color Saturation increased creating the surreal saturated look common to many HDR images.

Strength	70
Color Saturation	60
Luminosity	0
Microcontrast	+2.0

Smoothing

Min Low Mid High Max

☑ Light mode

▶ Tone settings

▶ Color settings

▶ Miscellaneous settings

☐ 360° image

Settings

Presets: Default ◆

☑ Save

OK

169

HDR Imaging

When I first wrote about High Dynamic Range Imaging in 2005, it was used more in CGI (Computer Generated Imagery) for controlling lighting effects than in photography.

Within a couple of years it was being used experimentally by a wide range of photographers eager to explore its ability to create hitherto impossible imagery. This is still a relatively new technology and we can expect more progress in techniques and tools. Nevertheless, it is tailor-made for several types of low light photography, including interiors with bright views out and bright city lighting. Both of these situations have huge dynamic ranges. I touched briefly on dynamic range on pages 18–19, but here it's important to distinguish between low and high. These are relative concepts, and for photography, it is the practical issue that decides. Essentially, if the dynamic range of the scene can be captured in a single exposure, with the possible exception of specular highlights, this is low.

Technically, therefore, 8 bits per channel is a low dynamic range format. 12-bit and 14-bit, which you can capture using Raw with a DSLR, cover considerably more, but unfortunately most of the extra range is crowded into the highlights, where it is not really needed in photography, and little in the shadows, where it is. All camera sensors, therefore, work in a low dynamic range. In terms of scene lighting, this is usually adequate as long as there are no light sources in the frame, and as long as you do not need to pull out detail from visually deep shadows. Low lighting situations, however, often do feature lights in shot. An interior lit with only one desk lamp can cover 10 stops from close to the lamp to a dark shadow under the desk, while the lamp itself can extend this by 4 or 5 stops.

CHURCH INTERIOR
Another classic HDR situation is the interior of a large church, or cathedral. HDR and tone mapping is able to open up deep shadow areas in the vaulting, while also rendering the much brighter stained glass windows accurately.

High dynamic range formats typically have 32 bits per channel, which alone expands the range hugely. However, the normal formats and color spaces, as well as the performance of monitor displays, use non-linear gamma encoding, and an important effect of this is that more of the bits are devoted to highlight information than to the shadow areas. In fact, the more bits per channel, the less efficiently the image is encoded digitally. To overcome this, HDR formats use their 32 bits per channel not as discrete allocations of pixel values, but as decimal points. Floating point encoding assigns a precise value to every pixel, rather than forcing it into the nearest pre-determined level. The result is that an HDR file format can

LIGHT SOURCE IN VIEW

HDR and tone mapping easily meets the challenge of images in which the major light source is in view, as in this modern tea-ceremony room in Tokyo. Note also the holding of highlight detail in the spotlit wall-hanging.

record a virtually infinite dynamic range.

An HDR format capable of recording these high ranges is one thing, but capturing is another. The technique involves making a series of exposures at different shutter speeds. In practice, 2 stops is the most convenient gap between exposures, and in order to avoid changing the structure of the image, it is better to alter the shutter speed than the aperture. A basic and effective way of shooting is to begin with an exposure that avoids clipped highlights, using trial and error and the camera's on-screen highlight warning. This is the shortest exposure of the series. Then lengthen the exposure time by 2 stops—4 times the exposure, in other words—and take the second exposure. Keep doing this until the darkest shadows in the scene appear fully exposed; this looks like gross over-exposure on the LCD screen.

There are a number of software options for combining a series such as this into a single HDR image. The result is a 32-bits-per-channel floating-point image that contains all the data from all of the exposures. It is, however, unviewable because nearly all monitors are 8-bit, and even the few with extended range are a modest 14-bit. The second part of the operation, therefore, involves compressing all of this data back down to 8 bits or 16 bits. There are a number of ways of doing this, but without any predictable best method. The essential difficulty is that the detailed execution of compressing a huge range into a small one depends on the nature of the image and on your interpretation of it. An HDR image has the potential to mimic human vision in its ability to take in a high dynamic range, but the eye and brain work quite differently. The subject is complex, but in perception the eyes scan in rapid, jerking movements known as saccades, and these multiple "recordings" are rapidly assembled in the brain into a coherent view. There is no way in principle of mimicking this in one flat image. The various stages of making an HDR image are covered in the following pages.

HDR Generation

Typically, the process of creating an HDR image begins with capture, which we dealt with on pages 158–161.

The ease of creating an HDR file depends very much on this stage, because while the generation is largely automated, the software expects certain things from the captured sequence. It needs to access the exposure information, which is carried in the EXIF header, the exposures need to be appropriately spaced across the range, the several frames need to be in reasonably close alignment so they can be matched, and for the same reason there should not be too much movement of objects within the scene. If all these conditions cannot be met there are ways of working around them, but with more difficulty.

An HDR generator is software that collates all the different exposure information from a sequence of exposures and then creates a single HDR image file. There are a number of generators available, some of them free, and while there are technical differences, for normal photography there is little to choose in performance. The most widely used are those supplied with Photoshop and Photomatix. In use, all are relatively quick. Once the range of captured images has been selected, the generator looks for the exposure data in the EXIF headers.

As both Photoshop and Photomatix can read Raw files, if you are shooting Raw there is no point whatsoever in first opening and adjusting the images with a Raw converter. All the information can be accessed directly by the HDR generator.

Once the 32-bit-per-channel HDR file has been created, it appears on screen as an extremely contrasty and sometimes dark image. A regular 8-bit monitor is no more able to display the full range of the image than an 8-bit file format is able to record all this exposure information. The viewing experience of an HDR file is predictably unsatisfactory, but to be practical there are few reasons for wanting to be able to look at the image at this stage, other than to check that nothing has gone seriously wrong, such as an image from another sequence wrongly added.

The final step in HDR generation is to save the image file in one of several formats, although many people choose to bypass this and go straight to tone mapping, in which case the HDR file is converted and lost. The two most commonly used formats are Radiance and OpenEXR. There are important differences between them, but more from the perspective of CGI and motion-picture special effects, where accuracy across the entire range and file size (because of the huge number of frames in, say, an animated movie) matters. From a photographic perspective any of the available choices in the Save As dialog will do. If you plan to archive the HDR file, though, you may want to consider one of the more compact formats, such as OpenEXR.

ROOFTOPS

Generating the HDR file is only the first step in creating
the sort of HDR image that we are increasingly familiar
with. The HDR file has to undergo a process known as
tone mapping before it can be viewed or printed.

Tone Mapping

The final stage in HDR Imaging is to create a viewable 16-bit or 8-bit image from the 32-bit HDR file.

This is neither predictable nor particularly easy to manage, although there are several software methods. Much depends on the original scene, how big a dynamic range it has, and the way you shot it, but for various reasons simply compressing it to fit a 256-level scale is rarely satisfactory. If there are very bright highlights, for example, a simple proportionate compression will result in an overall dark image with insufficient attention paid to the midtones. Because the many tones in the HDR file have to be assigned somehow to the much more restricted low dynamic range (LDR) file, the procedure is called tone mapping. The software that performs this operation is known as a tone mapping operator, sometimes referred to by the shorthand TMO. The several tone mapping operators available are the result of various ingenious algorithms that attempt to give a result that is a compromise between retaining tonal detail across the scale and looking realistic. This last, realism, is the biggest problem in tone mapping, because it represents a cross over between the subjective and the psychology of perception.

All of this means that in practice there is a considerable amount of trial and error, and you may often want to try out more than one operator to see which looks best for you in which situation. There are two classes of tone mapping operator (TMO); global and local. A global operator works on the entire range of tonal values in much the same way, as does, for example, a tone curve on any image (think of normal Curves or Levels operations in Photoshop). Global operators have the advantage of giving results that look photographically normal, therefore realistic, but they have the disadvantage of usually sacrificing detail and contrast in some areas of the image. A common example of a global operator is a pair of sliders controlling gamma and exposure. Playing with both will usually produce an image that is acceptable but often flat.

The second class of TMO is the local operator. These algorithms, which vary considerably in the principles on which they work, adjust the tonal value of each pixel according to its neighbors. This makes it possible to adjust local contrast, and potentially this is a very powerful way of mapping tonal values. Accordingly, one of the key adjustments here is the radius—the distance around each pixel that is searched. If you are already familiar and comfortable with other radius-based procedures, particularly unsharp masking and Shadows/Highlights in Photoshop, you will become accustomed to these local operators more easily. The advantage of a local operator is that it can handle even wide dynamic ranges with surprising efficiency. The disadvantages are that the results can often look false and over-detailed, there is a danger of halos around distinct areas (such as the sky close to a window frame or a horizon), the results are difficult to predict and the user settings are non-intuitive. Local operators need considerable assistance from various controls.

In both cases, global and local, it is normal for the image to need further work. Getting the tone mapping right in one go is difficult, often impossible. Local operators in particular

FULL-SIZE HDR

HDR tone mapping makes it possible to shoot in very contrasty lighting, such as in a bar and restaurant without special lighting, and still achieve an attractive and controlled result.

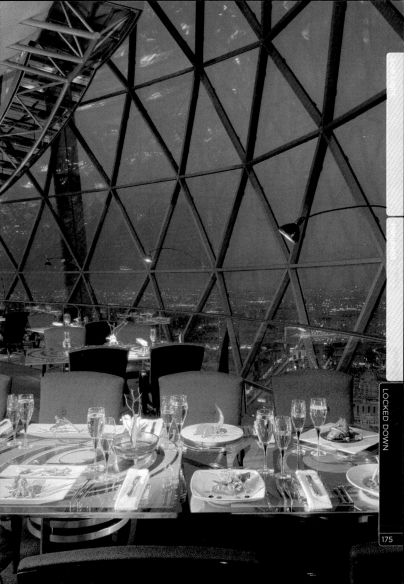

are likely to look rather flat. For this reason
it is essential to produce a 16-bit image from
the HDR 32-bit file. After further adjustment,
which would otherwise lose data and result
in a spiky, toothcomb-like histogram, you can
then reduce it to a final 8-bit image. The most
usual post-procedures for tweaking a 16-bit file
are Curves or Levels, Shadows/Highlights, and
even the mild local contrast enhancement of
USM used with a large radius and small amount.

Color saturation is another issue. Basically,
the more extreme the gradient of tonal
mapping, the more saturated the final color
is likely to be, and this often results in certain
colors appearing far too rich. Some local
operators have a color saturation control,
but in any case, you can expect to need to
perform some adjustment on the output
16-bit image. The Hue/Saturation sliders
are an obvious choice, but a more targeted
procedure is the Replace Color tool in
Photoshop's *Image > Adjustment* menu.

Tone mapping is, above all, very specific.
HDR software designed for photographers began
with Photomatix, was followed by Photoshop,
and now includes a few more, notably FDRTools,
EasyHDR, and Nik HDR Efex Pro. There will
undoubtedly be more to come. Each works
in a particular way, different from the others.

PROCESSED COMPARISON

In the processed comparison, the best original frame (LDR,
low dynamic range) is on the left; in the center is the HDR
global tone mapped version and on the right the locally
tone mapped version, both in Photomatix. Global tone
mapping does a satisfactory and realistic job of combing the
exposures, but comes nowhere near the local tone mapping
operator, which holds detail in each tonal neighborhood of
pixels, from highlight to shadow.

CHROMATIC ABERRATION

Lateral chromatic aberration is exaggerated strongly in the process of generating and tone mapping an HDR. This small detail from the corner of an image, uncorrected and corrected, gives an idea of the extent of this problem.

SEPARATED BY TWO F-STOPS

Enlargements of a detail—one of the spotlit dishes from the restaurant image on page 175—shows the original sequence of 3 frames, each separated by the standard 2 f-stops.

Photomatix

HDR using Photomatix

Photomatix is the pioneer HDR application for photography (as has already been noted, HDR has other uses, notably in computer-generated imaging), and in the current crop of available software is noted for the large number of user controls that it offers. One result of this is that it enables a wide range of possible treatments for any image, including some highly non-realistic ones. Photomatix offers a basic choice between Tone Compressor (its global operator) and Details Enhancer (its local operator).

As with other HDR software, the global operator sticks close to "photographic" realism, but is much less effective in tone mapping, so that with a wide range of exposures in the original sequence, the local operator—Details Enhancer—is the usual choice. The default setting gives a reasonable and realistic result under most circumstances, and it is best to begin with this. Photomatix offers a high level of control over all settings and more recent versions offer useful presets as starting points.

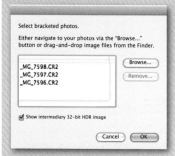

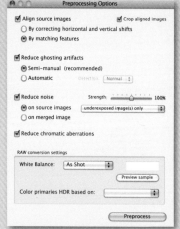

LOADING BRACKETED PHOTOS
Using Photomatix as a standalone program, begin the process by going to *File > Load Bracketed Photos*, and navigate to the image files.

PREPROCESS OPTIONS
Once you've clicked OK, the preprocess options include alignment of images based on content, always a useful precaution although it adds a little extra processing time, ghosting removal (unnecessary if there is no subject movement), noise and chromatic aberration reduction, and White Balance.

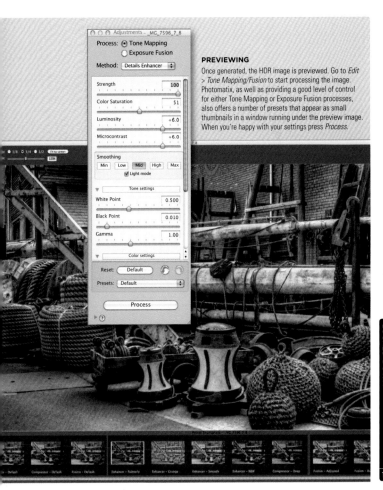

PREVIEWING

Once generated, the HDR image is previewed. Go to *Edit > Tone Mapping/Fusion* to start processing the image. Photomatix, as well as providing a good level of control for either Tone Mapping or Exposure Fusion processes, also offers a number of presets that appear as small thumbnails in a window running under the preview image. When you're happy with your settings press *Process*.

Photoshop

HDR using Photoshop

The Photoshop tone mapping procedure offers four ways of tone mapping, of which three are of little use. Exposure/Gamma is a straightforward pairing of an exposure slider (for brightness) and a gamma slider (for contrast combined with brightness), which offers very basic global tone mapping. Highlight Compression applies a custom tonal curve to reduce highlight contrast drastically so as to brighten the rest of the image and restore contrast. Equalize Histogram, applies a different custom tonal curve to even out peaks in the histogram. All of these are global operators. The most useful is Local Adaptation. In 16-bit mode this offers a good level of control over four key elements of the image, Edge Glow, Tone and Detail, Color, and Curve. There is also a limited number of presets to choose from.

PROCESSING

To begin the HDR process in Photoshop, go to *File > Automate > Merge to HDR Pro*. In the ensuing *Merge to HDR Pro* dialog box select the Raw files.

LAYERS CHANNELS PATHS

Normal Opacity: 100%

Lock: Fil: 100%

_MG_7596.CR2

_MG_7597.CR2

_MG_7598.CR2

Merge to HDR Pro

Default
Flat
Monochromatic Artistic
Monochromatic High Contrast
Monochromatic Low Contrast
Monochromatic
More Saturated
Photorealistic High Contrast
Photorealistic Low Contrast
Photorealistic
Saturated
Surrealistic High Contrast
✓ Surrealistic Low Contrast
Surrealistic
Custom

GENERATION

The HDR Photoshop generation process is automatic, and uses the layer system.

ADJUSTMENTS

Before the HDR is finally created, a preview window appears, showing the exposure settings calculated, and offering user adjustments to key elements of the image. There is also a selection of presets, although these are of limited use.

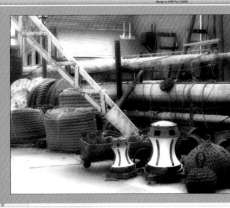

Preset: Custom

☑ Remove ghosts

Mode: 16 Bit Local Adaptation

Edge Glow

Radius: 181 px

Strength: 1.74

Tone and Detail

Gamma: 1.10

Exposure: 0.60

Detail: -30 %

Shadow: 0 %

Highlight: 0 %

Color Curve

Vibrance: 24 %

Saturation: 20 %

Cancel OK

HDR Efex Pro

HDR using HDR Efex Pro

Nik software's HDR Efex Pro is one of the more recent examples of HDR software. It has an attractive, user-friendly interface, with controls that will look familiar to anyone used to using image-editing software.

AS A PLUG-IN

When used as a Lightroom plug-in, simply select the various exposures of the image in the Library mode, and go to *File > Export* with Presets and select *HDR Efex Pro*.

Nik's HDR program offers localized adjustment in the form of Control Points. These allow you to make exposure, saturation, and contrasts adjustments to specific areas of the image.

EASE OF USE

Nik HDR Efex Pro is easy to use, offers a good level of adjustment and control, and features a variety of presets (visible down the left-hand side of the dialog box) that can be selected from a list of popular photographic genres.

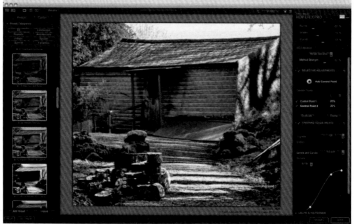

FDR Tools

HDR using FDR Tools

This piece of cross-platform software is notable for integrating the creation of HDR files from the source images with tone mapping. In other software this is a separate operation from tone mapping, with FDR Tools it is combined with the tone mapping in the sense that at any point during tone mapping you can return to the HDR creation and make a number of adjustments.

These include choosing which tonal ranges are used from which source images, tweaking the choice of images to use for ghosting removal, or even opting to drop one or more of the images. Although the interface is not as intuitive as other HDR software, FDR Tools is extremely powerful and versatile.

In the HDRI Creation panel it's possible to make tonal adjustments to the individual source files before finalizing the HDR process. These adjustments are previewed so you can see how they are likely to affect the outcome.

FDR Tools provides three tone mapping options. Simplex and Receptor are global operators, while Compressor is the local option. Many of the controls as well as being operated by sliders, can also be adjusted via curves, allowing you to apply levels of adjustment to specific tones. These provide a very high degree of control over the final image.

Ghosting

Ghosting is the term given to superimposed, displaced parts of an image, quite common in any multiple-exposure technique when parts of the subject move.

If you are shooting a scene with passers-by, for example, then it is inevitable that they will be in different positions in each of the frames. Moreover, as this is low light photography, some or all of the frames are likely to show a degree of motion blurring.

Many HDR generators, however, have some provision for attempting to remove ghosting. This works typically by detecting the variance in the image—the areas where the content differs—and then by giving priority to one frame of the sequence. This works most successfully when there are very few frames and movement in just one or two frames, as in the example here. Varied movement across a large number of frames, and in which the movement overlaps, can cause problems. It also helps when the movement is in an area with a similar tonal range, as movement across a strong luminosity edge, such as a skyline, can also cause failure. FDRTools notably allows adjustment of exactly how the frames are prioritized for ghosting removal, a useful option.

Finally, consider using the high-low ISO blending technique described on page 164. In this case you can expect tonal differences, but as the purpose is to select just moving subjects, such as people, this should not normally cause too many problems. When shooting, take one or a few frames at a sufficiently high ISO to allow a reasonably short shutter speed. The frame should in any case be in register with the HDR image. Paste on top after the HDR image has been tone mapped to 16-bit, check that it is in register

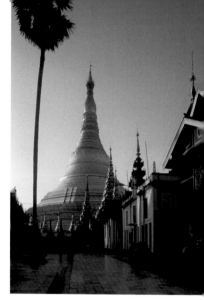

FIRST FRAME
The first frame, exposed for the sky and highlights on the pagoda.

by clicking this upper layer on and off quickly, and if any repositioning is necessary, do this now with the arrow keys. Next, erase around the objects you want to keep to replace their ghosted versions in the tone mapped HDR image, and adjust the tone and color to match, using Curves or Levels. Then you will need to flatten the image.

Illustrated on this spread is a simple situation for ghosting, with just two differently exposed frames, and so hardly HDR, but it illustrates the technique well. The two images were used to generate an HDR file in Photomatix, with ghost removal activated. For comparison, the result without ghost removal simply appears as a double exposure.

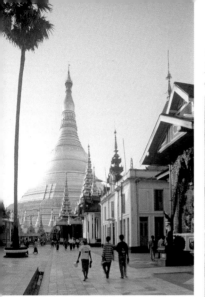

SECOND FRAME

Less than a minute later, the second frame, exposed for the shadow areas in the foreground, where the three people are walking.

DETAIL COMPARISON

In close-up, the area with the variance. On the top, without ghosting removal during HDR generation; on the bottom, with.

STANDARD COMBINATION

Combining the two images as a 32-bit-per-channel HDR image in Photomatix and then tone mapping. The blending of the two images without the option of removing ghosting has the predictable result of a 50% blend across the movement.

GHOSTING REMOVAL

Choosing the ghosting removal option during the HDR generation step prioritizes the second frame for the foreground.

Glossary

APERTURE

The opening behind the camera lens through which light passes on its way to the image sensor.

ARTIFACT

A flaw in a digital image.

BIT

(binary digit) The smallest data unit of binary computing, being a single 1 or 0.

BIT DEPTH

The number of bits of color data for each pixel in a digital image. A photographic-quality image needs eight bits for each of the red, green, and blue channels, making for a bit depth of 24.

BRACKETING

A method of ensuring a correctly exposed photograph by taking three shots; one with the supposed correct exposure, one slightly underexposed, and one slightly overexposed.

COLOR TEMPERATURE

A way of describing the color differences in light, measured in Kelvins and using a scale that ranges from dull red (1900 K), through orange, to yellow, white, and blue (10,000 K).

DEPTH OF FIELD

The distance in front of and behind the point of focus in a photograph, in which the scene remains in acceptable sharp focus.

FILL-IN FLASH

A technique that uses the on-camera flash or an external flash in combination with natural or ambient light to reveal detail in the scene and reduce shadows.

FILL LIGHT

An additional light used to supplement the main light source. Fill can be provided by a separate unit or a reflector.

FILTER

(1) A thin sheet of transparent material placed over a camera lens or light source to modify the quality or color of the light passing through. (2) A feature in an image-editing application that alters or transforms selected pixels for some kind of visual effect.

FOCAL LENGTH

The distance between the optical center of a lens and its point of focus when the lens is focused on infinity.

FOCAL RANGE

The range over which a camera or lens is able to focus on a subject (for example, 0.5m to Infinity).

FOCUS

The optical state where the light rays converge on the film or CCD to produce the sharpest possible image.

F-STOP

The calibration of the aperture size of a photographic lens.

GAMMA

A measure of the contrast of an image, expressed as the steepness of the characteristic curve of an image.

GRADATION

The smooth blending of one tone or color into another, or from transparent to colored in a tint. A graduated lens filter, for instance, might be dark on one side, fading to clear on the other.

HDRI

(High Dynamic Range Imaging) A method of combining digital images taken at different exposures to draw detail from areas that would traditionally have been over- or underexposed. This effect is typically achieved using specialist software, and HDRI images can contain significantly more information than

can be rendered on screen or even perceived by the human eye.

HISTOGRAM

A map of the distribution of tones in an image, arranged as a graph. The horizontal axis goes from the darkest tones to the lightest, while the vertical axis shows the number of pixels in that range.

HOT-SHOE

An accessory fitting found on most SLR cameras and some high-end compact models, normally used to control an external flash unit.

ISO

Traditionally an international standard rating for film speed, with the film getting "faster" (more sensitive to light) as the rating increases. ISO 400 film is twice as fast as ISO 200. The term is now used with digital cameras to represent the sensitivity setting of the sensor. Sensors have a native sensitivity of either 100 or 200 ISO, but can be increased (up to 6,400 or even 12,800) to make the sensor more sensitive to light, so producing a correct exposure with less light and/or a shorter shutter speed. However, higher ISO settings tend to produce more noise.

JPEG

(Joint Photographic Experts Group) Pronounced "jay-peg," a system for compressing images, developed as an industry standard by the International Standards Organization. Compression ratios are typically between 10:1 and 20:1, although lossy (but not necessarily noticeable to the eye).

LAYER

In image-editing, one level of an image file, separate from the rest, allowing different elements to be edited separately.

LUMENS

A measure of the light emitted by a light source, derived from candela.

LUX

A scale for measuring illumination, derived from lumens. It is defined as one lumen per square meter, or the amount of light falling from a light source of one candela one meter from the subject.

NOISE

Random pattern of small spots on a digital image that are generally unwanted, caused by nonimage-forming electrical signals.

PIXEL

(PICture ELement) The smallest units of a digital image, pixels are the square screen dots that make up a bitmapped picture. Each pixel carries a specific tone and color.

RAW

A digital image format that preserves higher levels of digital image information than traditional 8-bits-per-channel images. The image can then be adjusted in software—potentially by three f-stops—without loss of quality. The file also stores camera data including meter readings, aperture settings and more. In fact each camera model creates its own kind of Raw file, though leading models are supported by software like Adobe Photoshop.

REFLECTOR

An object or material used to bounce available light or studio lighting onto the subject, often softening and dispersing the light for a more attractive end result.

RGB

(Red, Green, Blue) The primary colors of the additive model, used in monitors and image-editing programs.

SATURATION

The purity of a color, going from the lightest tint to the deepest, most saturated tone.

SHUTTER

The device inside a conventional camera that controls the length of time during which the film is exposed to light. Many digital cameras don't have a shutter, but the term is still used as shorthand to describe the electronic mechanism that controls the length of exposure for the sensor.

SHUTTER SPEED

The time the shutter (or electronic switch) leaves the sensor open to light during an exposure.

SLR

(Single Lens Reflex) A camera that transmits the same image via a mirror to the film and viewfinder, ensuring that you get exactly what you see in terms of focus and composition.

TELEPHOTO

A photographic lens with a long focal length that enables distant objects to be enlarged. The drawbacks include a limited depth of field and angle of view.

TIFF

(Tagged Image File Format) A file format for bitmapped images. It supports cmyk, rgb and grayscale files with alpha channels, and lab, indexed-color, and it can use LZW lossless compression. It is now the most widely used standard for good-resolution digital photographic images.

WHITE BALANCE

A digital camera control used to balance exposure and color settings for artificial lighting types.

Index